Watercolour Painting
Pure and Simple

Watercolour Painting
Pure and Simple

Paint techniques that work
every step of the way

Joe Francis Dowden

SEARCH PRESS

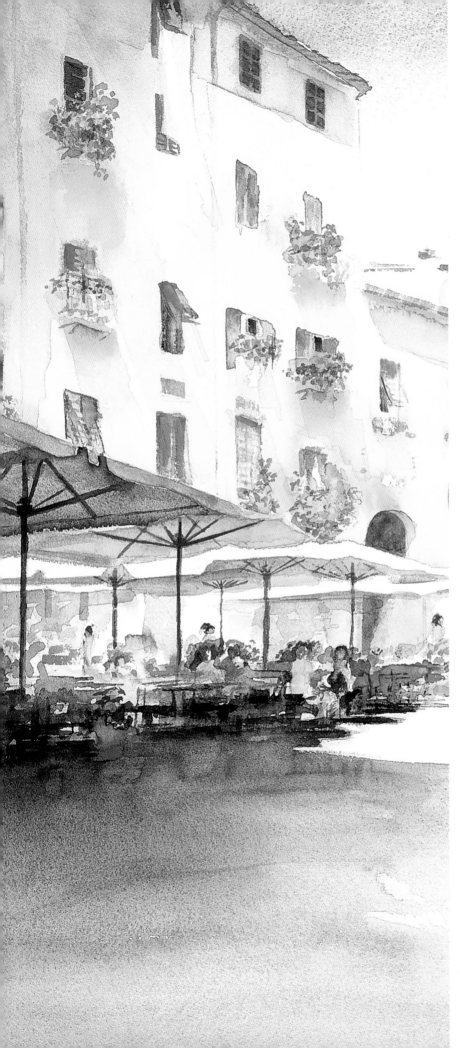

A QUARTO BOOK

Published in 2003 by Search Press Ltd.
Wellwood
North Farm Road
Tunbridge Wells
Kent
TN2 3DR

ISBN 1-903975-64-6

Conceived, designed and produced by
Quarto Publishing plc
The Old Brewery
6 Blundell Street
London N7 9BH

QUAR.SIWA

Editor: Kate Tuckett
Art Editor: Anna Knight
Designer: Tania Field
Photographers: Martin Norris, Paul Forrester
Assistant Art Director: Penny Cobb
Copyeditor: Jean Coppendale
Proofreader: Anne Plume
Indexer: Pamela Ellis

Art Director: Moira Clinch
Publisher: Piers Spence

Manufactured by
Universal Graphics Pte Ltd., Singapore
Printed by
Star Standard Industries Pte Ltd.,
Singapore

Contents

Introduction 6

Materials 8

Techniques 12
Colour mixing **14**
Washes
1 Flat wash **18**
2 Graded wash **19**
3 Multicoloured wash **20**
4 Lost-and-found edges **21**
5 Line and wash **22**
Brushwork
6 Wet in wet **24**
7 Wet on dry **25**
8 Drybrush **26**
9 Detail **27**
10 Stippling **28**
11 Feathering **29**
12 Gouache **30**
13 Light to dark **31**
14 Letting colour in **32**
15 Mottling **33**
16 Hard-and-soft edges **34**
Layering
17 Layering **36**
18 Glazing **37**
19 Wet-on-dry spatter **38**
20 Wet-in-wet spatter **39**
Reserving whites
21 Saving whites **40**
22 Masking **42**
Granulation
23 Granulation **44**
Special effects
24 Tissue paper **46**
25 Sponging **47**
26 Salt **48**
27 Dropping **50**
28 Sgraffito **51**
29 Ox gall liquid **52**

Projects 54

1 Wild poppies **56**

2 Fruit bowl **62**

3 Café at noon **70**

4 Reading in the sun **76**

5 Parrot in wild thicket **84**

6 Family portrait **90**

7 Tuscan vineyard **98**

8 Sailing in Zanzibar **106**

9 Copse of trees **112**

10 Broad sunlit river **118**

Index 126

Credits 128

Introduction

Simply Watercolour is designed to help you master all practical aspects of watercolour painting. Even if you are an absolute beginner, and have never tried painting before, if you follow the advice and suggestions here you will soon be able to paint any of the illustrated projects. Practise the different techniques and experiment with different styles, colours and subjects until you discover what works best for you.

One great advantage of watercolour is its simplicity. You can paint anywhere – in the home or out of doors – at any time, whatever your environment. The materials are easy to prepare and once the techniques have been mastered, they are often very simple, giving you the freedom to paint whatever you want.

Basic watercolour techniques are explained clearly and simply step by step; a photograph complements each step. The essential methods thus are broken down into easily understandable bite-size chunks. The techniques pages show you how to tackle the building blocks of watercolour. You can refer to them when you attempt projects in the book, or use them to paint what you want, how you want.

Natural beauty is inherent in the properties of watercolour materials. The transparency of the pigment, the whiteness of the paper and the endless variations of colours, which can be mixed very quickly, are some of the qualities that this book will teach you to manipulate. Watercolour is a great way to create a visual impact very rapidly. Just a few washes can be built up in minutes into an appealing and

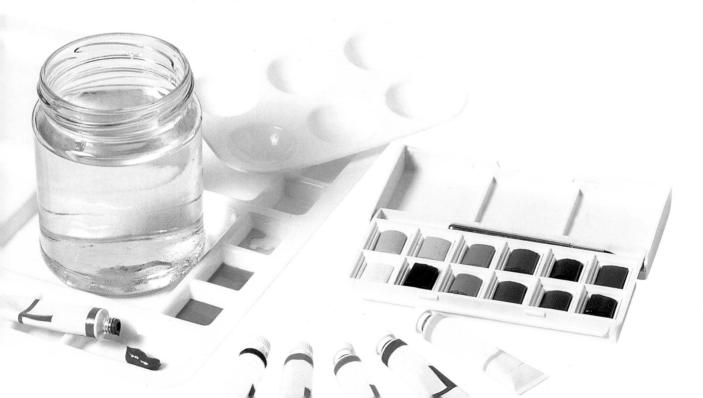

dynamic image. For example, paint that is brushed onto wet paper will spread very evenly and dry to a smooth finish, with no brushmarks. Leave a triangle of white paper and you have blue sea and sky, with sun shining on the sail of a boat.

A tropical bird in all its colourful glory, rolling vineyards of winemaking country, water, faces, flowers, trees, buildings – all these subjects are demonstrated here in logical stages to show you the huge range of possibilities, and to inspire confidence as you construct your paintings. The key to beautiful paintings is to let the watercolour medium work for you.

The transparency of watercolour makes it easy on the eye, and beautiful to observe even in a very simple painting. If you keep your work simple and don't try to do too much, you will maintain this characteristic of transparency.

The projects demonstrated in *Simply Watercolour* reveal how you can develop and master the principles of using watercolour to create beautiful paintings with confidence. Your work can be loose and light, or ablaze with colour and brilliance, and you don't have to set out to produce

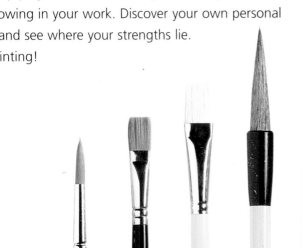

identical results by slavishly following each of the steps in your own paintings. Indeed, if the artists were to paint these projects again, they would come out differently. That's the beauty of watercolour – it is both unpredictable and transient – but those are also strengths, and ones that you can exploit. There are no rules in watercolour, only guidelines. There are dozens of techniques for you to choose from and it is up to you how you use them. Watercolour is fundamentally beautiful. Producing watercolour paintings is not a closed door. Beautiful results are accessible and eminently achievable.

Expand on your talent by building your confidence with these step-by-step projects. Gain encouragement as you see the results showing in your work. Discover your own personal direction and see where your strengths lie. Happy painting!

Materials

Watercolour has many advantages over other mediums and perhaps the greatest is that you need only a small amount of relatively inexpensive equipment to get started. In fact, the essential materials for painting in watercolour are just paint, paper, brushes and clean, clear water.

paint

Watercolour paints are designed to last for a long time. They behave quite unlike the paints used for signs, buildings, cars and so on, which reflect light from their surfaces to give us the image and the colour we see. Watercolour paint is different in that it is transparent. Lightwaves pass through it to meet the paper beneath, then bounce back through the colour. The whiteness of the paper literally 'lights up' the colour.

Watercolour paint excels when it is brushed and left without much interference. It is perfect for 'letting colour in', that is, simply letting colour flow off the tip of a brush into a wash of clear water, to give smooth passages of colour. If applied to dry paper with single brushstrokes it remains vibrant when it dries.

Ready-made watercolour paint is available **dry** or **semi-dry** as a **liquid** in **tubes** (1) or in **pans** (2); each has its advantages and disadvantages. It is priced in scales according to colour because some colours are more expensive to produce than others. Pigment on its own will not attach to paper reliably, so it is made with a binder, usually gum arabic, along with other substances. These carry the pigment and adhere it to the paper, as well as enabling the paint to flow and spread evenly.

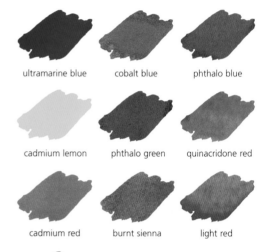

ultramarine blue	cobalt blue	phthalo blue
cadmium lemon	phthalo green	quinacridone red
cadmium red	burnt sienna	light red
Payne's grey		

You do not have to use all the colours mentioned in this book; there are always alternatives. Here is a suggested palette with which you should be able to paint almost any colour.

Cobalt blue is often used as a sky blue on its own or in colour mixtures. When mixed with burnt sienna it will also produce a range of warm and cool greys. Ultramarine blue, a warmer blue, will do this as well.

Ultramarine blue is closer to red on the spectrum, and can be mixed with **quinacridone red** to make violet, and with light red to make a strong grey.

Phthalo blue can also make a good sky colour, and with Payne's grey added to it produces a darker blue, perhaps of reflected sky in a river or the sea.

Cadmium red could be the base colour for poppies in a field. **Burnt sienna** is a warm, earthy brown, useful for a vast range of applications; a **light red** is a brick or tile red for buildings, also often used in portraits. **Payne's grey** can be used as a dark in your palette, such as when it is added to green for deep shadows in trees, woodland and foliage. Add a little **phthalo green** to a lot of **cadmium lemon** for a bright summer green, and moderate it with burnt sienna to create realistic foliage.

1

2

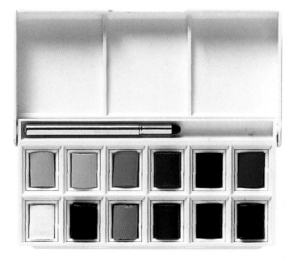

paper

Watercolour paper is very different from the paper we see around us in books and stationery cupboards. It loves water and will remain undamaged from a soaking; it is also strong enough not to rip when stretched, and delicate enough to produce the most beautiful effects. It will withstand a deluge as effectively as a city pavement, yet receive the brushstrokes needed to create an exquisite flower or the face of a child.

Watercolour paper is often made with traditional techniques that in principle are ancient. The result is a thick paper, made from natural fibres or modern fibres that perform in a similar way, which can cope with large quantities of water and pigment, but will reveal pale touches of colour equally well. It includes an agent that resists the pigment, keeping the pigment on the surface rather than allowing it to sink into the paper's fabric. It allows artists to paint with piercingly sharp clarity and accuracy when called for. There are many beautiful brands, all unique in their own way. Some of the best paper is made from cotton rag. As a general rule, the heavier the paper, the less it will buckle. A combination of stretching the paper and choosing the right weight will prevent buckling.

Paper weights

Sheets of watercolour paper come in different thicknesses. These are measured in weight – the heavier the indicated weight, the thicker the paper. The weight refers to a ream, which is 480 sheets, and not to individual sheets of paper. A lightweight, thin paper can be 90 lb. Medium-weight paper starts at 140 lb, while a heavier medium weight commonly used is 200 lb. Readily available heavy weights go up to 300 lb, with even heavier paper obtainable.

Stretching paper

Many artists stretch paper of weights up to 140 lb; some stretch heavier papers, although from 200 lb and up they should remain stable when not pre-stretched. You will develop your own instincts on this matter before you know it. Then you will have begun to make the art of watercolour your own!

Stretching paper involves wetting it at the outset, either by brushing water onto both sides or immersing it in water. Allow the surface water to drain off and, while the paper is still wet, attach it to a drawing board with paper tape, often called gumstrip; or alternatively, it can be stapled. You can also place a drawing pin at each corner over the gumstrip. The paper should be left to dry thoroughly before use.

When wet, paper expands. If stuck firmly enough while wet, when it dries it shrinks and becomes tight, like a drumskin. Thus wrinkling is minimized when washes of water are applied. I prevent buckling by stretching 200 lb medium-weight paper.

Types of paper

There are three basic watercolour paper surfaces, or variants of them. **Hot-pressed paper** (1) is made smooth by passing it through heated rollers after it is made. Often used for accurate botanical painting, it is used less by beginners and not at all for the expressive watercolours in this book.

Cold-pressed paper (2) is pressed between unheated rollers lined with felt mats that impart a texture, or 'tooth', to the paper's surface. It is the most popular paper and is referred to as 'not surfaced', which means it hasn't been hot pressed. It has a moderately rough texture, just enough for colour to drag off the brush and create many useful effects. The projects in this book are all done on cold-pressed paper.

Rough paper (3) is not pressed at all, and each brand has a distinctly characteristic rough surface. This rough surface acts as a moderating influence and helps control the flow of pigment, contributing to an even finish. This is useful for skies and other applications. Used fairly dry, pigment can be dragged across the surface to produce many textures. You should never underestimate the capacity of even the roughest paper to produce detailed accurate work, especially on larger paintings to be viewed at a distance.

Tinted paper (4), **cartridge (or drawing) paper** (5) and **tracing paper** (6) are all additional cheap and invaluable materials for the artist.

Paper can be purchased in **pads** (7) or in individual sheets; the latter are necessary for larger paintings. Similar to pads are **watercolour blocks** (8), where the paper is stacked and glued on all four sides. It remains in the pad until the painting is completed, and then is removed carefully by slicing all four sides. The surface remains stable, but not as effectively as with pre-stretched paper. A block is useful for sketching *in situ*.

brushes

Sizes

Soft brushes are normally used for watercolour painting. Large brushes are required to apply washes and large areas of colour. **Flat brushes** (1) or the larger **round brushes** are useful for this, from size #12 (2) upwards. A round brush is one which, though round when dry, forms a fine point when wet, and can put broad swaths of colour down or execute tiny detail. For accurate work, small round brushes (3) from #2 to #6 that point well are useful.

Synthetic or animal hair?

The traditional material of choice is sable but these brushes are expensive and become more so with brushes of higher quality fibre. However, they should last many, many years if looked after properly. Sable is springy and resilient, and the tip is firm and points well. These brushes carry a large amount of colour, yet release it easily, and clean rapidly. A top quality sable brush will return to a point with one flick of the wrist when wet. Kolinsky is a name to look for when seeking the best quality, but even this comes in different grades, so check in catalogues for information. Mail order is often the least expensive means of purchasing them.

Synthetic fibre brushes are much cheaper and have mimicked many of the qualities of sable brushes. They are more difficult to clean when changing colours. However, they have their own distinct qualities and can point well, making them useful for detailed work. Successful long-lasting synthetic brushes (made of nylon or a mixture of nylon and sable) are available, which have some of the qualities of sable, but at far less cost.

Squirrel-hair brushes (4) (known as camel hair) can hold even larger amounts of colour than sable and are useful as wash brushes in the larger sizes. They lack the firmness of sable and synthetic brushes, and lack the controllability needed for accurate, detailed work. However, they are excellent for skies, clouds and areas where large amounts of colour need to be applied. They are a fraction of the cost of sable brushes. Squirrel/sable composite brushes are available, which are less expensive than sable, but retain some of the qualities of sable for controlled or detailed work.

Different types of brushes

Goat-hair brushes are large, flat brushes with very soft and long whitish hair fibres, known as **hake**. Commonly known as **hake brushes** (5), these are useful for applying large amounts of colour rapidly. They are gentle, and cause minimum disturbance to any underlying colour. When wet, the long straight edge of the tip can be used to paint a range of shapes.

Flat brushes (1) of different sizes are useful for rendering architectural details. Windows can be neatly brushed with a single stroke of a flat brush. Roofs and tiles can be rendered convincingly with speed and accuracy, producing straight edges with little effort.

Hog's-hair brushes (6) can be a useful tool for lifting colour, as well as applying large amounts where accuracy is not important. A small, flat hog's-hair brush can be used to lift colour neatly and create useful negative shapes in an image.

Chinese brushes (7) are a useful alternative to sable. These can create detail as well as superb flowing lines – for example, the branches of trees.

Suggested brushes to start with are #2 and #4 round brushes made of either sable or synthetic fibre, for fine detail. A #6 or #8 round sable can be used for the bulk of most painting, and good quality brushes will let you do fine detail because they form such excellent points. A #16 round squirrel fibre brush can be used for applying colour to large areas. A #6 flat brush will enable you to paint architectural details, such as window apertures, with a single stroke.

pencils

Most paintings start as light pencil sketches. These can be done separately on a piece of cartridge paper or a drawing pad, readily available from catalogues and art shops. After sketching the image, you can draw it lightly onto watercolour paper. Pencils are graded with a number and a letter.

H means hard and B means soft, with HB in the middle. The higher the number, the harder or softer the pencil – for example, 4H is quite hard, 4B quite soft. Suitable pencils for use on watercolour paper range from about HB to 2B (moderately soft). I favour a B or 2B for my preparatory drawing.

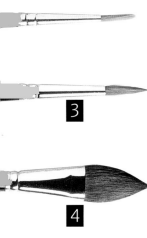

materials list

A few additional materials can be added to your equipment, including:

Clean water
Paper
Cartridge paper
Drawing pads
Tracing paper
Paper for cutting stencils
Card for cutting stencils
Palettes for mixing
China plates
Manufactured mixing palettes

Watercolour paper (cold pressed, i.e., not surfaced)

Arches 140 lb
Whatman 200 lb
Bockingford 200 lb
Fabriano Artistico 300 lb
Saunders Waterford 140 lb
Hahnemuhle 200 lb

Wooden watercolour board

Brushes

Sable round, #1, #2, #3, #4, #6, #8, #12, #16
Sable flat, #12
Squirrel mop, #20 or #22
Squirrel flat, 5mm (³⁄₁₆"), #25
Squirrel filbert, #22
Hake (large flat brush)
Synthetic round, #1, #4, #8
Chinese #13 (squirrel hair, traditionally bound Oriental brush)
Woodcock feather (brush)

Pens and Pencils

Colour shaper
Ruling pen
Pencils: HB, B, 2B, 3B, 4B
Pencil sharpener
Indian ink pen and nib
Fine line pen
Technical pen
Eraser
Paper tape, artist's tape
Masking tape
Drawing pins

Other items

Water spray
Craft knife
Scalpel

Scissors
Palette knife
Sponge
Toothbrush
Paper towels

Aluminium foil
Cling film
Candle
Cotton buds
Tracing paper
Bubble wrap

Other mediums

Granulation medium
Ox gall liquid
Masking fluid
Gum arabic
Sea salt in large and small grain sizes
Salt – ordinary, fine grained

Paint

Pan and tube watercolour paints

Indian yellow *burnt umber*

new gamboge *permanent yellow*

cadmium yellow *aureolin yellow*

quinacridone gold *cadmium orange*

Bruegel red *rose doré*

brilliant pink *alizarin crimson*

quinacridone violet *quinacridone magenta*

dioxazine mauve *dioxazine purple*

manganese blue *cerulean blue*

Prussian blue *cobalt turquoise light*

indigo *turquoise blue deep*

Prussian green *green gold*

Hooker's green *terre verte*

cobalt teal *viridian*

Chinese white *titanium white*

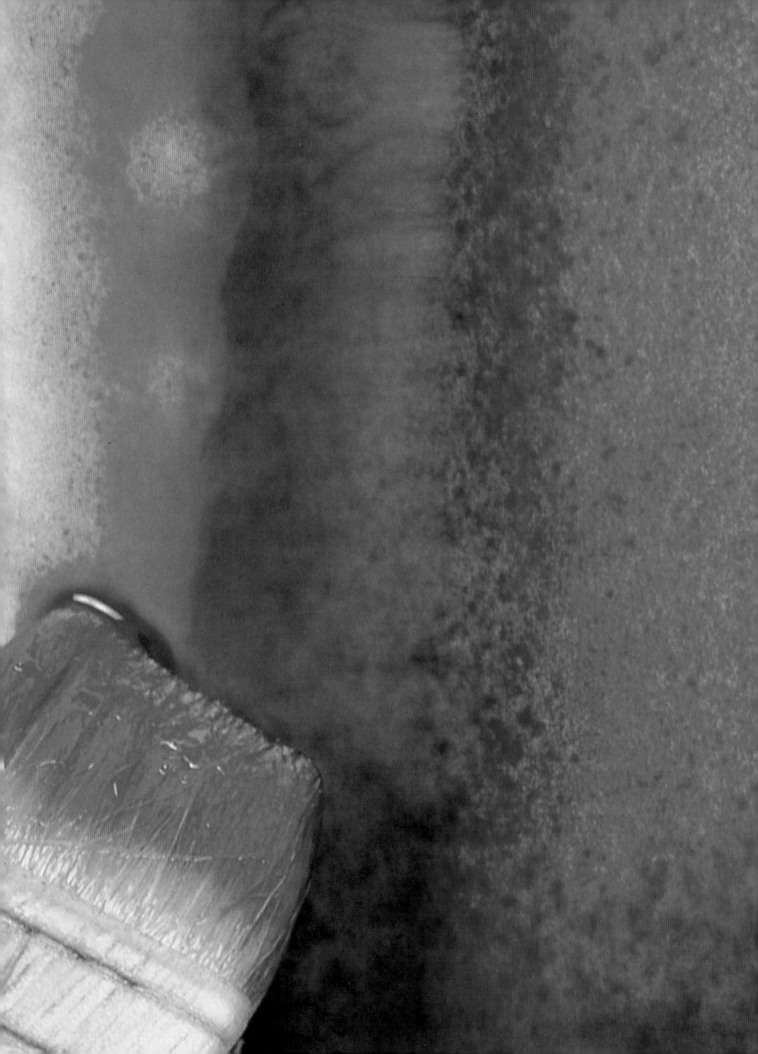

Techniques

A huge number of techniques lie at the
watercolour artist's disposal. When combined,
these create a sophisticated repertoire of effects,
allowing you to develop your own unique style.
This section moves through a consideration of the
most basic washes to more specialized finishes,
such as knife scratching and stippling. Step-by-
step instructions are given for each technique,
with full consideration of its application for a
variety of subjects.

colour mixing

Colour mixing

The possibilities for mixing different strengths and tones of colour, as well as colour combinations, are endless. Watercolours can be mixed on a plate or in a specially designed palette. Watercolour paints come in two forms – liquid in tubes and dry or semi-dry in cakes or 'pans', which are designed to clip to a paintbox. All of the following procedures can be completed with either pan or tube paints, although where larger amounts of colour are required, tubes can be easier to use as they provide large quantities of colour quickly.

weak-consistency colour

1 Squeeze a small amount of colour out of a tube onto the mixing palette. Permanent rose is used here. Thoroughly wet a brush by dipping it into clean water, and then brush a puddle of water onto the palette. Drag some of the paint into the puddle with the brush to create a watery mixture.

2 Drag the loaded brush across the paper, reloading it with the mixture of paint and water when necessary. Overlap the previous wet band of colour a little, so that the new strokes blend perfectly with the old ones.

medium-consistency colour

Go back to the palette and drag some more paint into the watery mixture you have already created to make a stronger mix of the same colour. Apply this stronger mixture to the weak wash of colour, 'wet in wet', to make a denser wash. This is still transparent, but much more vibrant. The light white of the paper still shines through the layer of colour, like light shining through coloured glass. Smoothness in sky washes can be achieved by starting with pale and watery colours, then adding a denser colour wash while they are still wet.

strong-consistency colour

1 Now mix the remaining colour on the palette to create a strong mixture of colour and water.

2 Brush the stronger mixture onto a new area of the paper to create a vibrant swath of rich colour.

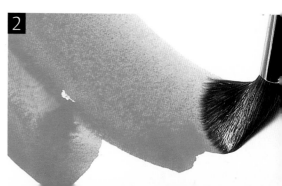

painting large areas

1 Squeeze plenty of colour from a tube onto a palette.

2 Dip a #8 brush into clean water.

3 Mix the water with the paint to form a reservoir on the palette.

4 Use broad strokes to apply large amounts of colour to the paper, making sure that sufficient paint is produced at the start to complete the wash without having to go back and mix more colour.

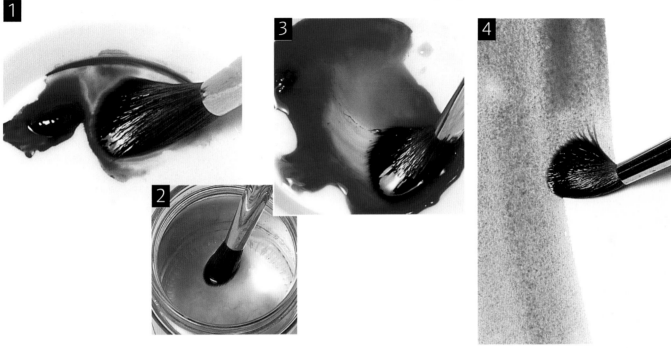

painting small areas

1 Squeeze a small amount of viridian – a cool bluish green – onto the palette and add water with a small brush: a large brush would absorb too much colour and none would be left on the palette.

2 The colour can now be applied to the paper with the same brush that applied the water to the palette.

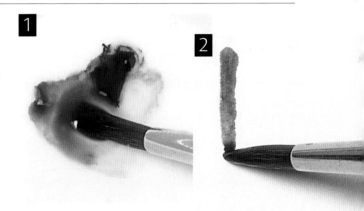

adding water to colour

1 Always keep a container full of clean water nearby. Apply permanent yellow – a vibrant and pure shade – with clean water.

2 Note the difference when the yellow is applied after having been mixed with dirty water.

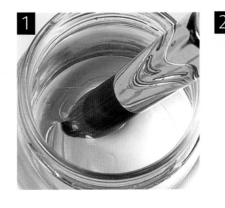

colour mixing

1 There are many ways of achieving a dark mix other than using black colours from the pan or tube. One way is to mix ultramarine blue and light red. This combination makes a beautiful grey, with a large range of subtle hues that can be mixed in any strength up to a virtual black. Ultramarine blue and Indian red produce a more intense dark. Here ultramarine blue and light red are mixed on the palette to create a dark grey.

2 This is one of a range of subtle greys from ultramarine blue and light red, painted in a transparent wash by adding plenty of water to the mix before applying the paint to the paper.

3 Manufacturers' greens are often very strong. It can be necessary to add yellow to them for a more natural look. Start with a yellow such as cadmium lemon or new gamboge. Add a smaller amount of a green, such as phthalo green or Hooker's green, until the paint is the desired colour. Here cobalt teal was added to permanent yellow to get a bright green.

4 A cobalt teal and permanent yellow mixture is brushed into a medium consistency transparent wash.

5 Adding white to a colour can make it pale and creamy – here Chinese white is mixed with cadmium red.

6 This is a wash of cadmium red and Chinese white. It is usually better to get paler tones in watercolour by adding water rather than white paint. A colour mixed with a white pigment is sometimes known as a 'tint'.

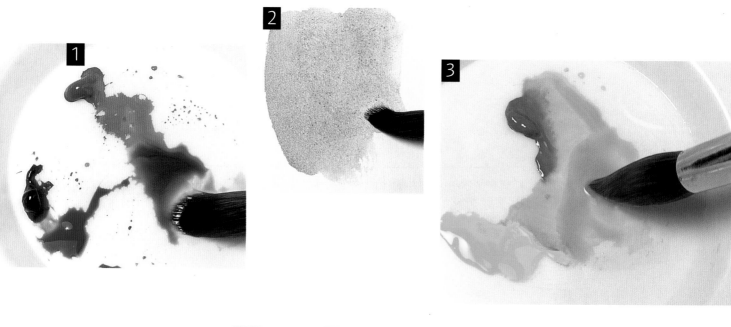

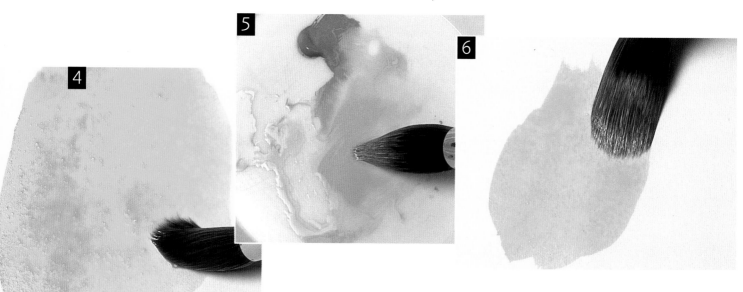

7 Black can be added to a colour to darken it. Here a black is added to cadmium red to get a greyish red.

8 There are many ways of achieving this colour without using a black – adding green, for example, will do more or less the same thing. However, black has a place in the watercolour painter's palette and many artists use it.

9 Mixing three colours can result in a convincing shade. Cobalt teal, permanent yellow and burnt umber are prepared on the palette.

10 Cobalt teal and permanent yellow are mixed to create a bright green.

11 A little burnt umber is mixed into this to moderate the colour and create a very natural green.

12 Light and dark greens are demonstrated on watercolour paper.

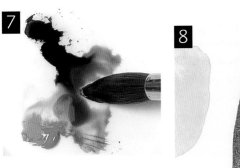

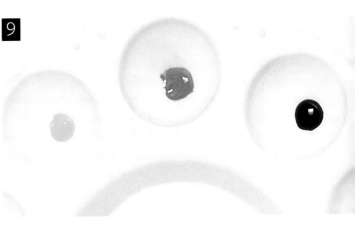

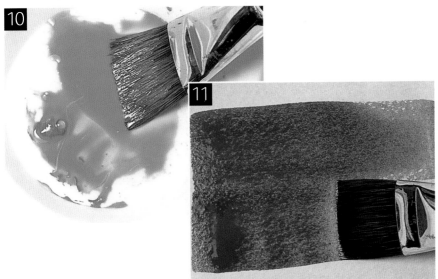

tip

For the many greens of nature, such as grass or trees, start with yellow rather than green. Next add green in small amounts until you have the colour of your choice. Finally, add burnt umber or burnt sienna to the colour to tone it down and make it look more natural. As you progress with the colour mixing, don't rely on the look of the colour on the palette – test it out on a spare piece of watercolour paper.

washes 1·Flat wash

materials

Colour:
cadmium red

Watercolour paper:
140 lb cold pressed

Hake brush

Palette consisting
of separate pans

**Two containers of
clean water,**
one for mixing and diluting
your paint and one for
rinsing your brush.

The watercolour wash is one of the basic building blocks for watercolour painting, and the flat wash is the simplest of these. It is the easiest method for applying colour to the paper, and probably the very first exercise for the beginner in watercolour.

1 With a sheet of dry paper, start at the top left corner, or the opposite corner if you are left-handed. Using cadmium red diluted with water, drag the brush across the paper. It will leave a broad band of colour behind. A flat brush like this hake brush can be used, or a large round brush such as a #12 upwards. Keep in mind that round brushes actually form a point when wet.

2 Carry on dragging the brush across, reloading it with paint and water. Overlap the previous wet band of colour a little, so that the new stroke blends perfectly with the old one.

3 Each successive stroke enlarges the expanse of colour without leaving any brush marks.

painting sequence

1

Paint across the paper from left to right as though you were drawing with a pencil.

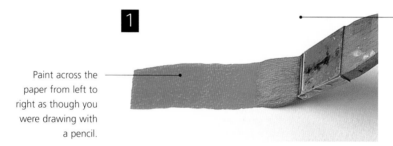

The board can be either tilted at a 30° angle, or horizontal.

Try to work as quickly as possible as you need to lay the next stroke before the previous one dries.

2

Do not overpaint an area while wet, or it will result in an uneven wash.

If you work the wash with confidence and without retouching, the finished wash will be smooth all the way down and without any marks.

3

The paint should be mixed with roughly the same amount of water for this wash.

washes 2·Graded wash

Producing a graded wash is a simple way of getting a really good sky, fading perfectly as it descends towards the land. The wash gets paler from top to bottom, in a gentle graduated effect. A good result can be obtained easily but don't look for perfection; no two graded washes are the same.

1 Mix a pool of ultramarine blue on the palette and have a jar of clean water at hand. Starting at the top with a large brush, paint a broad band of colour, loading plenty of water and colour on the brush. Paint straight across a couple of times, one band below the other, as with the flat wash technique.

2 Dip the brush in clean water (rather than paint) and paint a band of diluted colour below the still-wet previous band.

3 Add more water to the brush for each band.

4 Each band is thus paler and blends smoothly into the one above.

materials

Colour:
ultramarine blue

Watercolour paper:
140 lb cold pressed

Hake brush

Palette consisting of separate pans

Two containers of clean water, one for mixing and diluting your paint and one for rinsing your brush.

painting sequence

1
Each new stroke will lift any excess water from the previous stroke.

2
Start to paint at the top of the page where the colour is at its most intense.

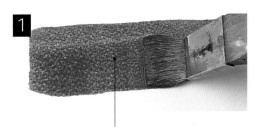

3
Remember that each wash should be only one step lighter than the previous one, so don't dilute too quickly.

4
Don't rinse the brush between bands of colour, as this prevents a smooth progression of colour flow.

Plenty of water will be required in this mix, as the paint becomes more and more dilute.

Colours are seldom flat or one solid hue, so a finished graded wash often gives a realistic effect.

washes 3·Multicoloured wash

materials

Colours:
ultramarine blue, cadmium
red, cadmium yellow

Watercolour paper:
140 lb cold pressed

Hake brush

Palette consisting
of separate pans

**Two containers of
clean water,** one for mixing
and diluting your paint
and one for rinsing
your brush.

Having the option to apply a multicoloured wash is one reason why water-colour is such an ideal medium with which to paint. Colours can simply be blended together, allowing the natural wetness of the paper and the flow of the pigment to do the work for you. This technique can be applied to skies, which have many different colours, and all the background tones for a painting can be applied in one go at the beginning.

1 Paint an ultramarine blue wash onto the dry paper.

2 Continue brushing this colour across the paper, working lower down and keeping it wet.

3 Add broad strokes of cadmium red to the base of the blue wash, then brush some cadmium yellow across the base of the wet red colour.

4 The final wash consists of three blending bands of colour – like bands of light across an evening sky.

painting sequence

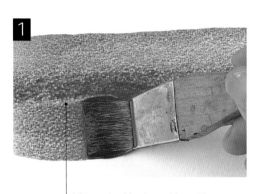

Make sure that you have prepared the different colours before you start so that you can apply the wash while the paint is still wet.

Ultramarine blue is used here. To paint a sky, other blues can be used, such as phthalo blue, cerulean blue or cobalt blue.

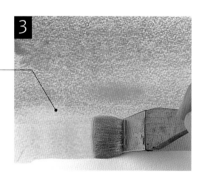

The colours will start to blend before they dry.

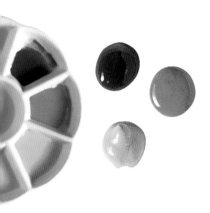

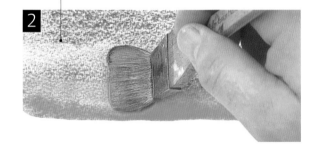

The finished result can be used as a background with more detailed work over the top of it.

4·Lost-and-found edges

A wash with a defined edge on one side and a faded edge on the other is known as a lost-and-found edge. Lost-and-found edges are useful for depicting smoothly graduating shadow on rounded objects. Here the technique is used for the tones and shadows on rounded hills, but it can also be used to apply shade and 'body' to subjects such as a tree, log or cloud, or for defining the light on snowdrifts.

1 Wet a portion of paper with clean water.

2 Add the colour above the wet area with a clearly defined wavy edge along the top.

3 Without reloading the brush, carry the colour down into the wet area. Allow the colour to bleed down, fading to the white paper. Dry with a hairdryer.

4 Wet another area below the dried paint. Paint above this wet area, forming a defined line on the dry paper but again fading into the wet paper below. Dry as before.

materials

Colour:
Hooker's green

Watercolour paper:
140 lb cold pressed

Hake brush

Sponge

Palette consisting of separate pans

Two containers of clean water, one for mixing and diluting your paint and one for rinsing your brush and sponge.

painting sequence

1

2

A sponge is used here, but a large brush can also be used.

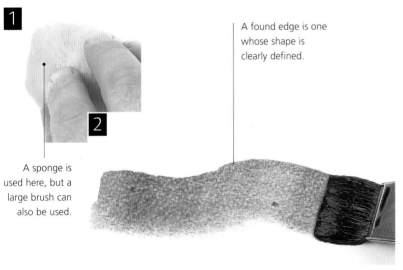

A found edge is one whose shape is clearly defined.

3

Lost edges tone into another colour, or another intensity of the same colour.

4

Once the paint is dry, it forms a series of waves, like a succession of hills in a landscape, with sharply defined edges fading down to white paper.

Lost-and-found edges are a good way of determining light and dark areas and areas of shadow.

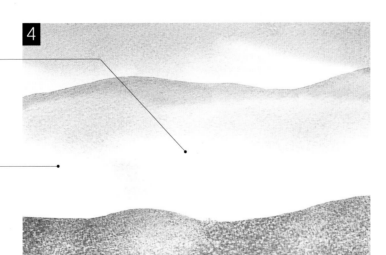

Mix a moderate quantity of paint and water and see how far it spreads.

5·Line and wash

Colours: green gold, phthalo blue, brick red

Watercolour paper: 140 lb cold pressed

Indian ink pen

#8 brush

Palette consisting of separate pans

Two containers of clean water, one for mixing and diluting your paint and one for rinsing your brush.

Line and wash is a type of visual shorthand, a rapid way of conveying information. Combining line to indicate form, with colour from the brush, can give much information with great economy, and produce an image with beauty in its own right.

The tone comes from 'hatching' – drawing numerous fine lines with a pen or other instrument. This can be supplemented with dark washes, perhaps for windows or doorways on a building. Satisfaction often comes with brevity of expression, so it can be a real advantage to stop short of completing a very detailed image.

Inks can be waterproof or non-waterproof and both can be used in line and wash. Non-waterproof inks will run and add to the loose expressiveness of the medium. Loose-flowing lines and washes do not have to be completely precise. Line and wash is a medium enjoyed by painters and art lovers alike – extreme realism is not necessary. Lines can also be added after painting.

1 Draw a few short strokes, lines and markings with an Indian ink pen, by first dipping it in the ink pot and then drawing directly on the paper. Start by experimenting with the pen on another sheet of paper.

2 Brush a loose wash of green gold across the ink. Waterproof ink, which does not run, has been used here.

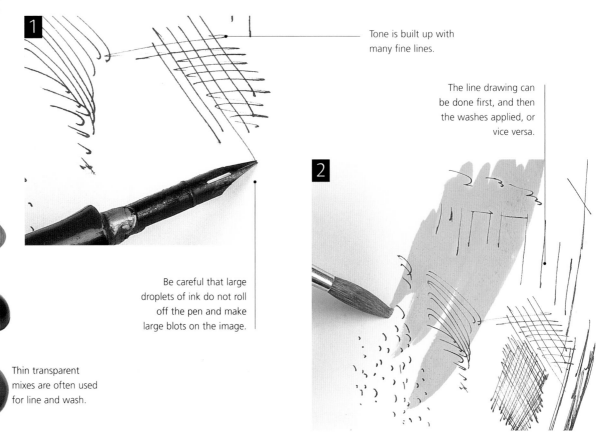

1

Tone is built up with many fine lines.

The line drawing can be done first, and then the washes applied, or vice versa.

2

Be careful that large droplets of ink do not roll off the pen and make large blots on the image.

Thin transparent mixes are often used for line and wash.

3 Now brush phthalo blue across the paper. Notice how the transparent quality of this colour, even though it is quite intense, allows the linework to show through – this is the essence of line and wash.

4 Finally, brush light red across the image; this is a useful muted brick red, often used for architectural work.

5 Leave some of the linework unpainted so that it remains sharp and focused.

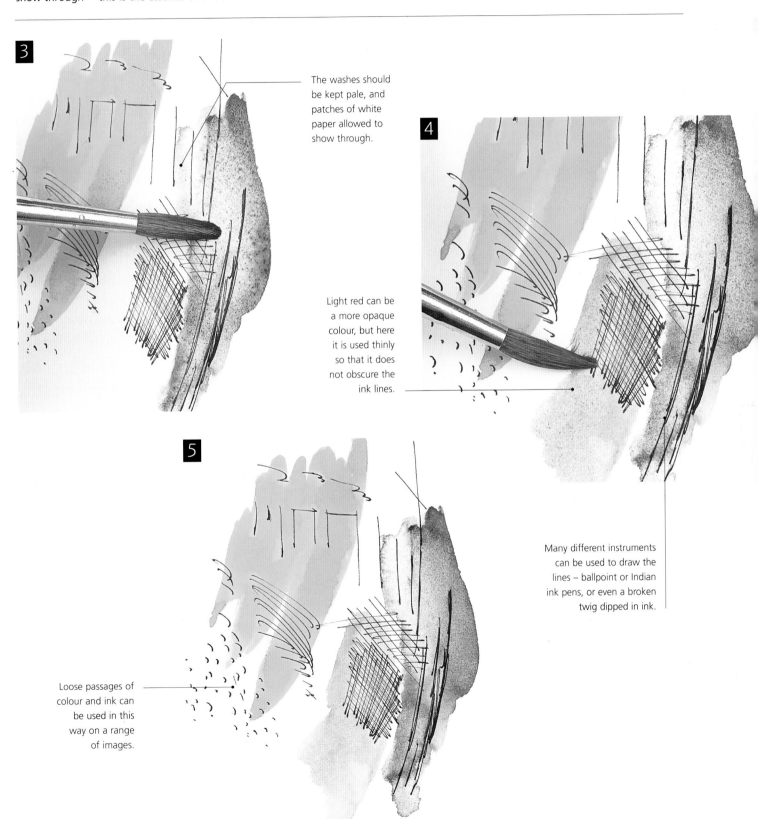

3

The washes should be kept pale, and patches of white paper allowed to show through.

4

Light red can be a more opaque colour, but here it is used thinly so that it does not obscure the ink lines.

5

Many different instruments can be used to draw the lines – ballpoint or Indian ink pens, or even a broken twig dipped in ink.

Loose passages of colour and ink can be used in this way on a range of images.

6·Wet in wet

Working wet in wet is one of the classic watercolour techniques and produces wonderful, soft effects possible only in this medium. The term means exactly what it sounds like – painting into colour that is still wet, or onto paper that is damp. Where two washes touch, they blend to produce a third colour. It's worth experimenting to see the subtle effects you can achieve by applying light colours over dark, or dark over light.

materials

Colours: quinacridone gold, ultramarine blue

Watercolour paper:
140 lb cold pressed

#12 brush

#6 brush

Palette consisting of separate pans

Two containers of clean water, one for mixing and diluting your paint and one for rinsing your two brushes.

1 Using clean water, wet your paper using a #12 brush, quickly covering the surface area. Leave to dry slightly.

2 Apply patches of quinacridone gold before the paper loses its essential glistening quality. Apply small quantities of paint at first, otherwise you may cover too much of the paper.

3 While the paper and the quinacridone gold are wet, apply the ultramarine blue between the patches of quinacridone gold. It's important to get the consistency of the washes right. If they are too thin, the paint will bleed too much. They should be a creamy consistency, similar to whole milk.

painting sequence

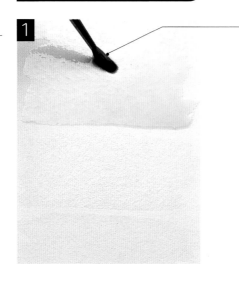

1 Make sure your brush is scrupulously clean when wetting the paper, or it will affect the paint colours. Do not over-wet the paper, or it will be saturated.

2 Allow the colour to spread over the damp surface, creating a feathery edge.

The centre of the paint patch retains its original quality. You can use rough paper for a more speckled surface; the wash will run into the tiny indentations to produce a slightly spotty effect.

Make sure the wash does not start to dry before adding wet colour. Wet colour pushes the pigment along, forming an edge and causing a 'cauliflower' effect.

Use bold, intense mixtures here, as they will be diluted when they are applied to the wet paper.

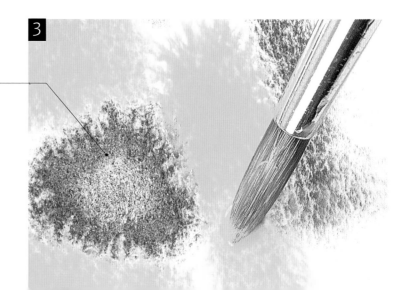

<div style="brushwork">**brushwork**</div> 7·Wet on dry

Accurate work is possible by simply painting lines, or drawing with the brush. Brushes can be very accurate drawing instruments and can be used to impart their shape effortlessly to give a vast range of natural-looking marks for branches, ripples in water, grass and rocky crags – the list is endless.

1 Dip a #8 brush into some burnt sienna and drag a line along the paper, simply letting the natural flow of the brush create the line. The pigment flows out of the tip and onto the surface of the paper.

2 Get the feel of what the brush and paint do to help you become familiar with the properties of watercolour. A #8 is useful for the expressive strokes of nature and when using large amounts of colour accurately but quickly.

3 A variety of strokes can be made with any brush. A smaller, #2 was used here with ultramarine blue to create thin lines. A #2 is a good brush for detailed watercolour. As the brush is pulled gently across the surface of the paper it creates a drybrush effect by only leaving paint on the slightly rough surface of the paper, producing a slightly rough texture. Using more water produces a paler line. Using more paint and water produces a rich fluid mark.

materials

Colours: burnt sienna, ultramarine blue

Watercolour paper: 140 lb cold pressed

#8 brush

#2 brush

Palette consisting of separate pans

Two containers of clean water, one for mixing and diluting your paint and one for rinsing your two brushes.

painting sequence

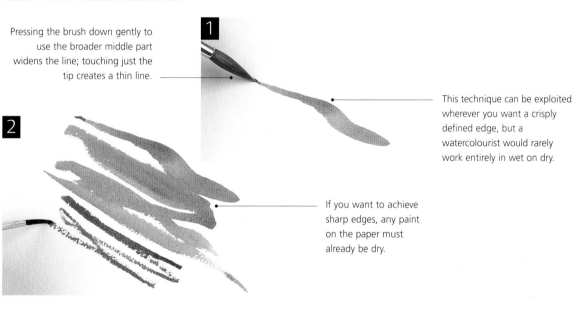

Pressing the brush down gently to use the broader middle part widens the line; touching just the tip creates a thin line.

1

This technique can be exploited wherever you want a crisply defined edge, but a watercolourist would rarely work entirely in wet on dry.

2

If you want to achieve sharp edges, any paint on the paper must already be dry.

3

Lines of different thicknesses can be produced with ease, using the point of the brush.

Bold, thick mixtures allow you to explore the properties of the paintbrush.

brushwork

8·Drybrush

materials

Colour:
phthalo green

Watercolour paper:
140 lb cold pressed

#8 brush

Palette consisting
of separate pans

**Two containers of
clean water,** one for mixing
and diluting your paint and
one for rinsing
your brush.

Drybrush means that your brush is almost dry or only slightly damp before it is loaded with paint. It is a useful technique for fine detail, for producing leaves, rough texture for stones, grass, wood grain, the surface of the sea or rough water and a host of other textures.

1 Use phthalo green on a #8 brush, and paint on cold-pressed, or rough paper. Use the side of the brush to 'glance' over the surface of the paper.

2 By experimenting you will soon find the optimum pressure when dragging the brush to give this rough texture on the paper.

3 A directional effect can enhance the roughness of the paint for a beautiful grained effect.

painting sequence

Mix the paint into a rich consistency.

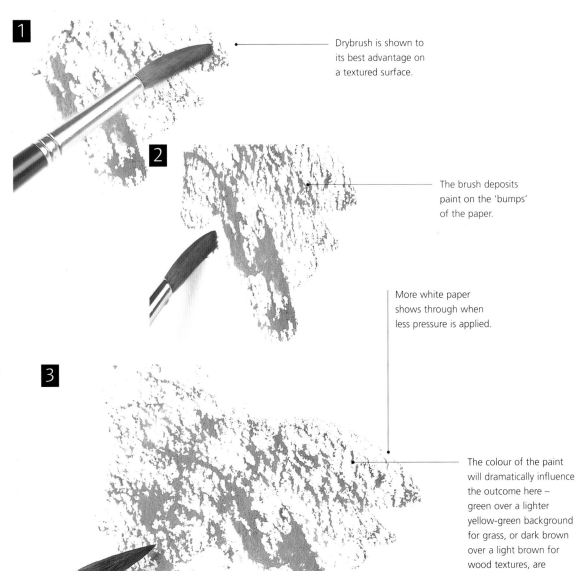

Drybrush is shown to its best advantage on a textured surface.

The brush deposits paint on the 'bumps' of the paper.

More white paper shows through when less pressure is applied.

The colour of the paint will dramatically influence the outcome here – green over a lighter yellow-green background for grass, or dark brown over a light brown for wood textures, are possibilities.

brushwork 9 · Detail

This technique involves literally drawing with the brush, a pencil or other drawing instrument. Brushes can be accurate and easily controllable – there is no detailed drawing that cannot be done with a brush.

1 Use a small brush that points well. Here a #3 was used to produce wavy lines of quinacridone magenta. Clean the brush before changing colour.

2 Brush small cobalt blue shapes onto the paper, letting the brush dictate the shapes. Discover the properties of the brush and its versatility at producing many different shapes.

3 Use the sharp point of the brush to make stars of cadmium orange. The zigzag line of phthalo green shows that a constant thickness can be maintained if desired.

4 Define the edges of the triangles with phthalo green and loosely fill in these shapes.

materials

Colours: quinacridone magenta, cobalt blue, cadmium orange, phthalo green

Watercolour paper: 140 lb cold pressed

#3 brush

Palette consisting of separate pans

Two containers of clean water, one for mixing and diluting your paint and one for rinsing your brush.

painting sequence

1

Use the tip of the brush, sometimes holding it almost vertically.

2

Brushwork can be done without any pencil drawing underneath.

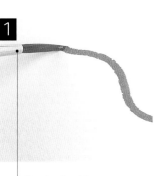

Paint the details with a very fine brush. Where a crisp line is required, do not dampen the paper first.

3

Watercolour brushes can make regular geometric patterns or the flowing lines of nature with ease.

4

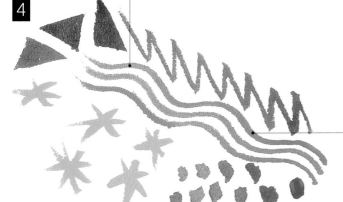

A relaxed approach will help to enhance the natural fluidity of the paint that flows from the brush, allowing the spring and firmness of the fibres to guide your work.

The consistency of the paint here can vary from thin and watery to thick and rich.

10·Stippling

Stippling can produce the perfect texture for many things – the rows of vines in a vineyard, the rough texture of ground or the mottled face of a cliff. It produces a distinct texture that is quite different from other techniques, so knowing how to apply it can add to your ability to convey a vast number of possibilities in watercolour.

1 Here an old sable brush is loaded with cadmium red and just dotted down onto the surface.

2 Load a large flat hake brush liberally with a mixture of Payne's grey and alizarin crimson. Shake the brush firmly so that the fibres separate into clumps. Next, dab it down repeatedly in a broad line to give roughly parallel lines of texture, like ploughed furrows in a field.

3 The marks from stippling create various possibilities – clumps of ferns or tire tracks could be implied by these marks.

painting sequence

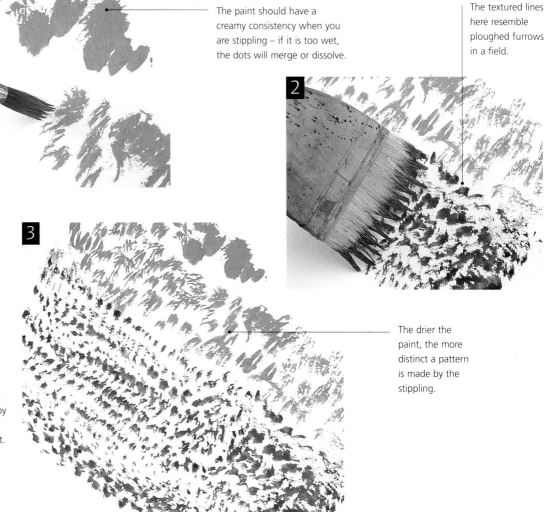

1 The paint should have a creamy consistency when you are stippling – if it is too wet, the dots will merge or dissolve.

2 The textured lines here resemble ploughed furrows in a field.

3 The drier the paint, the more distinct a pattern is made by the stippling.

Distinct patterns can be created by applying various consistencies of paint. Here the paint was thick and strong.

brushwork 11·Feathering

The inherent qualities of paint and the expressiveness of the brush can be enhanced to produce a convincing stand of pine trees or branches in a forest canopy. Stunning results belie the simplicity of the technique and help confirm watercolour as a superb medium for rendering the natural world.

1 Load a brush with a mixture of alizarin crimson and phthalo green. Put this to one side and, with another brush, loosely drag several strokes of water across the paper. Careful attention is needed to see that the water touches only the rough surface. Drag the wet brush gently but firmly along the surface so that the tooth of the paper 'grabs' some of the moisture, while many of the tiny pits and dimples in the surface texture remain dry. This is a little like drybrush, except that water rather than paint is used. Leave gaps between the strokes of water.

2 While still wet, brush a mix of alizarin crimson and phthalo green in parallel lines at right angles to the strokes of water.

3 See how the strokes diffuse sideways, creating the perfect tracery of branches for a pine forest. This is one application of water feathering. Another is to brush water loosely at different angles, still leaving plenty of dry paper, and brush the twisting branches of a tree or forest through the brushed water.

materials

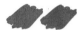

Colours: phthalo green, alizarin crimson

Watercolour paper: 140 lb cold pressed

#8 brush

Palette consisting of separate pans

Two containers of clean water, one for mixing and diluting your paint and one for rinsing your brush.

painting sequence

1

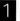

Pressing too hard with the water will soak the paper, so be careful at this stage.

2

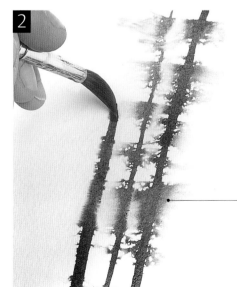

Note the effect as the lines of paint pass across the lines of water.

3

It's important to have all the colours mixed before you start this technique, as there is little time between the various stages.

The paint needs to be strong and wet so that it spreads well here.

12·Gouache

Colours: phthalo green, alizarin crimson, titanium white, cadmium red

Watercolour paper: 140 lb cold pressed

#8 brush

Palette consisting of separate pans

Two containers of clean water, one for mixing and diluting your paint and one for rinsing your brush.

It is often best to achieve highlights in watercolour by saving them at the start, but another way to get light for certain subjects is to add a little white to the paint and paint over the darker colour underneath. Certain colours are opaque enough to overpower underlying darks, but adding white will increase this capacity. This technique can be useful for rendering small things, such as stalks or blades of grass where they have to be lighter than their surroundings. Sometimes just a few gouache strands of grass over a green wash in the foreground can make the grass effect more convincing.

1 First paint a dark wash of phthalo green and alizarin crimson.

2 When the wash is completely dry, the mark shown here is mixed by adding titanium white to the colour and brushing it on.

3 Make additional marks with this colour. More titanium white can be brushed on while the colour is still wet to give it more body and light. It can also provide a graduated effect for a twisted blade of grass catching the light at one point along its curve. Mix cadmium red and titanium white and brush on to give a red with body.

4 More colour can be added when everything is dry. This can give a stronger colour or a brighter highlight, as gouache tends to absorb darker pigment from underneath before it dries.

painting sequence

1

Make sure that the underlying wash is as dark as possible.

Remember that watercolour paint dries a weaker shade than when it is applied, so add plenty of white to make it show up.

Body colour creates highlights and defines the edges of shapes.

2

Adding gouache can mask out overworked or confused areas.

4

White highlights can be used as a glint on leaves, the name or number on a boat or daisies in a field.

3

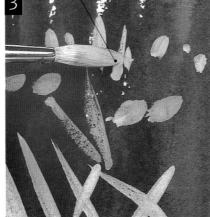

The pigments should be dense and creamy here.

brushwork 13·Light to dark

Working from light to dark is the process of laying down colours one over the other in succession. Each is left to dry before the next is applied, each one darker than the last. This technique forms the basis for watercolour.

1 Using cadmium lemon, criss-cross the paint in random strokes, building a rough pattern and leaving white paper between the strokes. Leave this to dry.

2 Add a little phthalo green to some cadmium lemon to make a green. Brush this over the yellow. Allow some white paper and yellow to remain between the strokes of colour. Leave to dry thoroughly.

3 Brush a few rough marks of phthalo green. A complete texture of tones from light to dark has now been built up.

materials

Colours: cadmium lemon, phthalo green

Watercolour paper: 140 lb cold pressed

#8 brush

Palette consisting of separate pans

Two containers of clean water, one for mixing and diluting your paint and one for rinsing your brush.

painting sequence

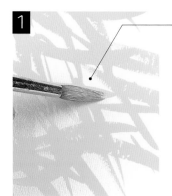

Allow plenty of white paper to show through the rough pattern you are creating.

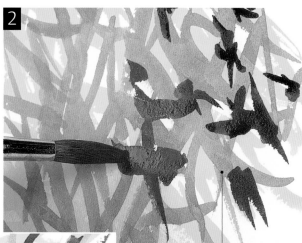

You can build up a painting in a succession of colours by using this simple principle.

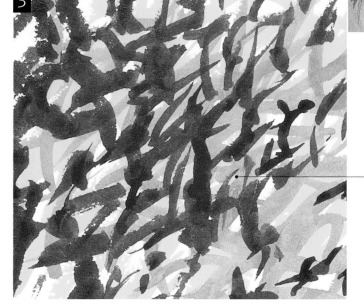

The finished result is especially useful for leaves and foliage.

Initial washes are transparent and need more water. Later ones are more intense, needing more pigment.

14·Letting colour in

Colours:
cadmium red, Hooker's green,
ultramarine blue

Watercolour paper:
140 lb cold pressed

Chinese brush

Palette consisting
of separate pans

**Two containers of
clean water,** one for mixing
and diluting your paint
and one for rinsing
your brush.

To achieve really smooth blocks of colour in a painting, you can wet the paper first and allow the colour to spread from the point of the brush into the wet areas to produce patches of vibrant, transparent colour. If you get marking or runs, it often doesn't matter – that's the nature of watercolour. Learn to live with what you get and exploit it as you develop your technique.

1 Make flower-shaped patches on the paper with clean water.

2 Clean the brush and load it well with colour. Here cadmium red has been used. Touch the brush onto the edge of the wet patch.

3 Fill all the remaining shapes in the same way. You can go over the wet areas with the brush, or simply allow the colour to spread across. Notice how the colour changes from dark to light, varying in tone to produce a miniature graded wash. Allow to dry.

4 Paint clean water between the red shapes, and then add Hooker's green to the water. Spread this around the red colour. Next, wash ultramarine blue onto the sky while the green is still wet, bringing it down and letting it blend with the lower part of the painting.

painting sequence

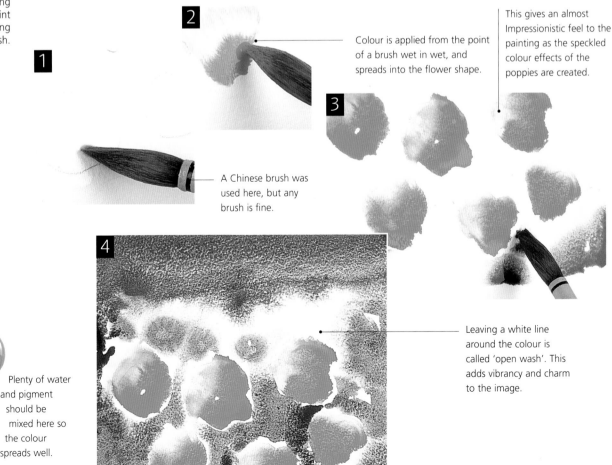

Colour is applied from the point of a brush wet in wet, and spreads into the flower shape.

This gives an almost Impressionistic feel to the painting as the speckled colour effects of the poppies are created.

A Chinese brush was used here, but any brush is fine.

Plenty of water and pigment should be mixed here so the colour spreads well.

Leaving a white line around the colour is called 'open wash'. This adds vibrancy and charm to the image.

brushwork 15·Mottling

This is an immensely useful technique for painting woodland trees and branches. It seems to present the labyrinth of tiny twigs exactly as they appear. It would be impossible to paint every little mark, but this rapidly creates the effect of instant tree texture.

materials

Colours: phthalo green, Payne's grey

Watercolour paper: 140 lb cold pressed

#4 brush

#6 brush

Palette consisting of separate pans

Two containers of clean water, one for mixing and diluting your paint and one for rinsing your two brushes.

1 Paint squiggly lines in an interlacing pattern. Phthalo green and Payne's grey were mixed here and applied with a #4 brush.

2 Finish painting the lines and, before they dry, spatter clean water over them from a #6 brush by firmly tapping it over your hand or fingers, letting droplets fly off onto the paper.

3 The paint from the lines diffuses into a tracery of colour where the droplets have landed on them, but in other places is untouched.

painting sequence

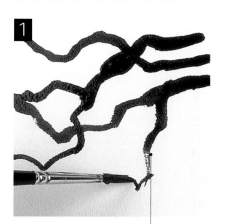

1

Ensure that you use a strong colour to paint the original lines. Do it this way and the original shape of the branches will be clear after the spattering has taken place.

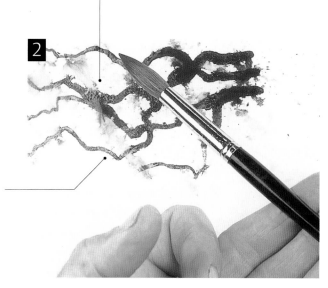

Note the detail as the paint from the lines diffuses outwards.

2

Make sure that you start spattering before the paint has dried.

3

You can really see the effect of many spreading branches in a woodland canopy here.

A rich, wet, free-flowing mixture works best here.

16·Hard-and-soft edges

materials

Colours: terre verte, Payne's grey

Watercolour paper: 140 lb cold pressed

#8 brush

Palette consisting of separate pans

Two containers of clean water, one for mixing and diluting your paint and one for rinsing your brush.

A stroke of colour can have a slightly softened edge, perhaps for the top of a woodland seen from a distance, where the soft-edged foliage meets the sky in your painting, or the edge of a shadow on a summer path. This technique will give you the soft edge you require.

1 Brush on some patches of colour. Terre verte mixed with a little Payne's grey was used here.

2 Before they dry, brush clean water into the gaps between them, keeping the water away from the colour.

painting sequence

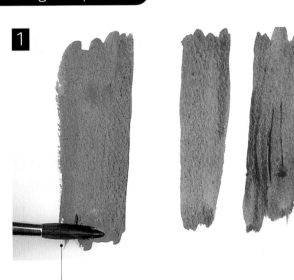

Make sure that the wet areas only correspond to the soft edges.

Use a #8 brush to achieve even, broad swaths of colour.

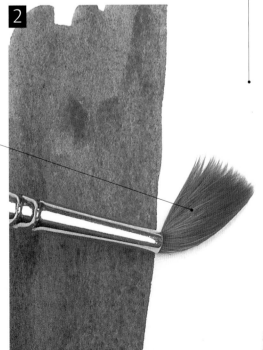

Water can be brushed along the side of the bands of colour with either a brush or a sponge.

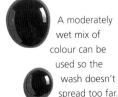

A moderately wet mix of colour can be used so the wash doesn't spread too far.

3 Next, again before they dry, brush water along one side of each patch of colour, joining it to the areas brushed with water. The colour flows into the water to produce a soft edge to one side of the panel. The other side has a sharply defined edge.

4 Finish the first panel, then do the same with the second and third.

5 Dry with a hairdryer.

6 The swaths of colour have a soft-focus edge on one side and a sharply defined edge on the other.

3

The colour flows into the water here to produce a soft edge to one side of the panel. The other side has a sharply defined edge.

Soft edges add expression to a painting and prevent it from becoming too stiff or static.

4

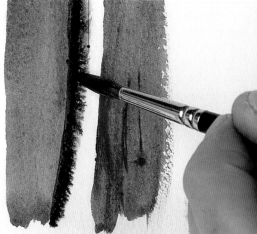

Soft edges can loosen up images and allow the eye to travel around the composition more easily.

5

The effect is more dramatic when the paint has dried than when it is still wet.

6

layering

17·Layering

materials

Colour:
cadmium yellow

Watercolour paper:
140 lb cold pressed

Hake brush

Palette consisting
of separate pans

**Two containers of
clean water,** one for mixing
and diluting your paint and
one for rinsing
your brush.

Multiple layers of paint in the same colour affect its intensity. Different colours are produced when two are superimposed, and tone intensifies with the depth of pigment. Washes of colour can be painted individually, but as they interact they can be used to build a composition of great complexity.

1 Paint a square, flat wash of cadmium yellow.

2 Repeat this process, painting a square within the original square.

3 Paint successive layers; vibrancy and intensity will increase where the layers are multiplied.

painting sequence

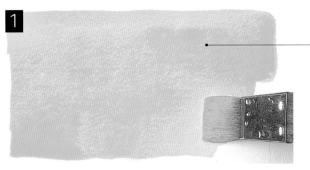

Using an intense colour such as cadmium yellow really shows off the vibrant build up of tone that is exploited here.

Each layer of colour must dry thoroughly before the next is applied.

The natural transparency of each layer reveals those underneath – this is the basic principle of watercolour.

Wet, vibrant mixes are necessary to maintain both the brightness and also the transparency of the paint.

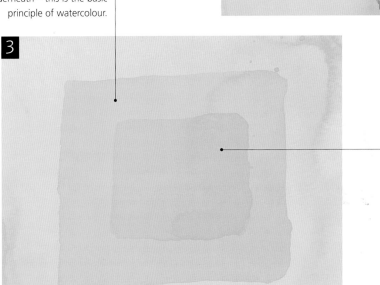

No more than two or three layers should be applied for optimum effect, unless the layers are very thin, as too many layers can reduce the natural vibrancy of watercolour.

layering 18·Glazing

Glazing is the process of painting one colour over another previously dried colour. The two then combine to produce another colour. Paintings can be built up with a succession of washes glazed over the underlying colour. When washes, or glazes, are applied over colour they can disturb the underlying colour a little, but not unduly if they are applied without working into them again while wet.

1 Paint bands of colour using alizarin crimson, ultramarine blue and permanent yellow, using a large flat hake brush.

2 Dry thoroughly with a hairdryer.

3 Next paint a band of alizarin crimson across the three other colours. Ideally brush the colour across just once and leave it to dry. Then brush across a band of permanent yellow, followed by a band of ultramarine blue. Notice the different properties and opacities of different colours. The horizontal bands of colour deepen or change the vertical bands underneath.

materials

Colours: alizarin crimson, permanent yellow, ultramarine blue

Watercolour paper: 140 lb cold pressed

Hake brush

Palette consisting of separate pans

Two containers of clean water, one for mixing and diluting your paint and one for rinsing your brush.

painting sequence

1

Washes of colour are transparent. When painted on white paper the white tone, which shines through from underneath, gives the wash its vibrancy.

2

Drying the colours as you proceed ensures a clean line when the colours merge.

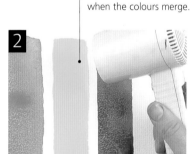

3

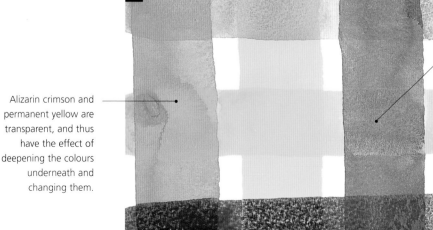

Alizarin crimson and permanent yellow are transparent, and thus have the effect of deepening the colours underneath and changing them.

The finished glazing shows the colours underneath glowing through.

Keep the mix bright and watery, as with Technique 17.

layering 19 · Wet-on-dry spatter

materials

Colours: cadmium lemon, phthalo green

Watercolour paper:
140 lb cold pressed

#8 brush

Palette consisting of separate pans

Two containers of clean water, one for mixing and diluting your paint and one for rinsing your brush.

This technique is a useful method of getting a vast quantity of natural-looking marks onto the paper in a short time. It can be useful for anything where rough organic shapes are required, such as sunlit leaves in a forest.

1 Using a #8 brush, spatter cadmium lemon onto dry paper by banging the brush down onto the palm of the hand.

2 Let the image dry and repeat the process with phthalo green for a layered texture.

3 Complex patterns can be built simply and rapidly using this approach.

painting sequence

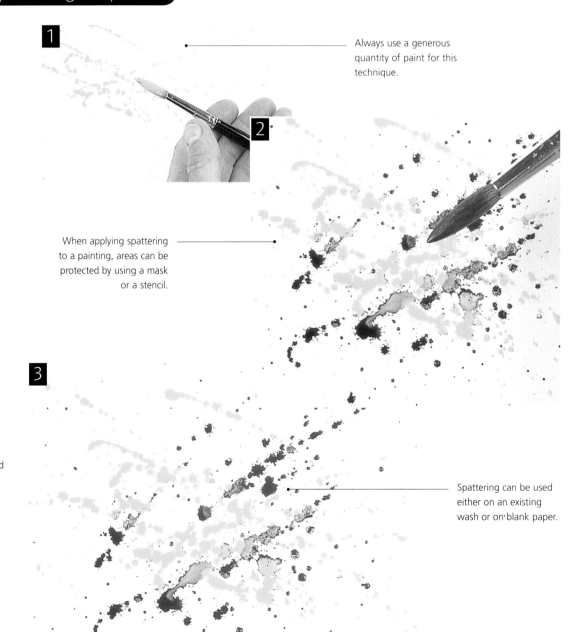

Always use a generous quantity of paint for this technique.

When applying spattering to a painting, areas can be protected by using a mask or a stencil.

The mixes for this need to be strong, with a lot of water, and the brushes need to be well loaded.

Spattering can be used either on an existing wash or on blank paper.

layering 20· Wet-in-wet spatter

Paint can be spattered onto wet or damp paper for a mottled texture, or it can be spattered onto water which has itself already been spattered onto the paper. This latter technique (shown here) gives a sophisticated pattern – two textures effectively interacting. It is convincing as undergrowth texture, producing a maze of shapes rather than separate markings. It can also simulate shadows around layers of leaves, or tangled plant masses.

1 Spatter water onto the paper. Use clean water on a #8 brush.

2 Dip the brush in the colour – phthalo green was used here – and spatter the colour onto the still-wet water spatter. As you continue to spatter you will notice there are two types of shape, and some of these flow into each other to form a maze of colour.

3 A #8 brush is used with a generous loading of water or colour, and cleaned between each separate stage. When dry, spatter water again and then spatter a dark colour, such as indigo, onto the water. This produces the darker shadows between the foliage. The result is a labyrinth of colour, tone and texture.

materials

Colours: phthalo green, indigo

Watercolour paper: 140 lb cold pressed

#8 brush

Palette consisting of separate pans

Two containers of clean water, one for mixing and diluting your paint and one for rinsing your brush.

painting sequence

1

As an alternative to spattering the water here, a plain wet wash can be applied.

2

Banging the brush down on the palm of your hand will achieve vivid star shapes from drops of water hitting the paper with force.

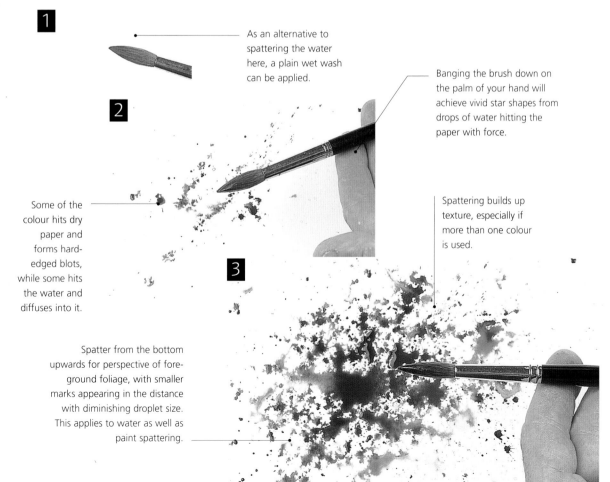

Some of the colour hits dry paper and forms hard-edged blots, while some hits the water and diffuses into it.

3

Spattering builds up texture, especially if more than one colour is used.

A rich, wet mix is needed here, similar to the mix described in Technique 19.

Spatter from the bottom upwards for perspective of fore-ground foliage, with smaller marks appearing in the distance with diminishing droplet size. This applies to water as well as paint spattering.

reserving whites

21·Saving whites

materials

Colours:
cadmium red, Payne's grey, ultramarine blue

Watercolour paper:
140 lb cold pressed

Chinese brush

Palette consisting of separate pans

Two containers of clean water, one for mixing and diluting your paint and one for rinsing your brush.

Saving whites simply means deciding before you begin a painting not to paint on certain areas of the image, but to leave the white of the paper to act as the whites needed for the image. This is part of the art of watercolour and can seem difficult, but if you bear in mind the exact shapes of the whites needed in the finished painting, you simply avoid painting them from the start. Initial light washes can be used to paint around these saved whites at the beginning, and help to define them so you know where they are. You can then continue to avoid these areas throughout the painting. Good use of saved whites can lift a painting from being ordinary to something special.

1 Lightly define cloud tops with a pencil. Create a patchy block of wet using clean water and a sponge or a brush. Leave the cloud tops marked in pencil dry.

2 Use a mixture of Payne's grey and ultramarine blue and paint this into the wet areas from the point of a brush. Be careful to save the whites of the cloud tops, and a little more in the lower cloudbank.

painting sequence

1

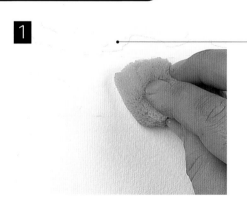

Make sure that you leave the cloud tops, marked in pencil, dry when you are sponging water onto the paper.

2

Already you can see the saved whites standing out from the painted area.

Use a weak, watery mixture for sky colours.

3 Wet the sky area above the clouds and brush in some ultramarine blue.

4 Bring the ultramarine blue down to the tops of the clouds and define the ragged cloud edge with this colour.

5 Add a little more ultramarine blue. Go back to the still-wet cloud area and touch some cadmium red into the base of the cloud.

6 Many different colours can be used on the base of the cloud. Ultramarine blue, yellow ochre and alizarin crimson mixed together can make a variety of grey shades biased towards orange, red, violet or blue. An easy grey to mix is burnt sienna and cobalt blue or ultramarine blue. Neutral tint can be another useful cloud grey, and there are many more.

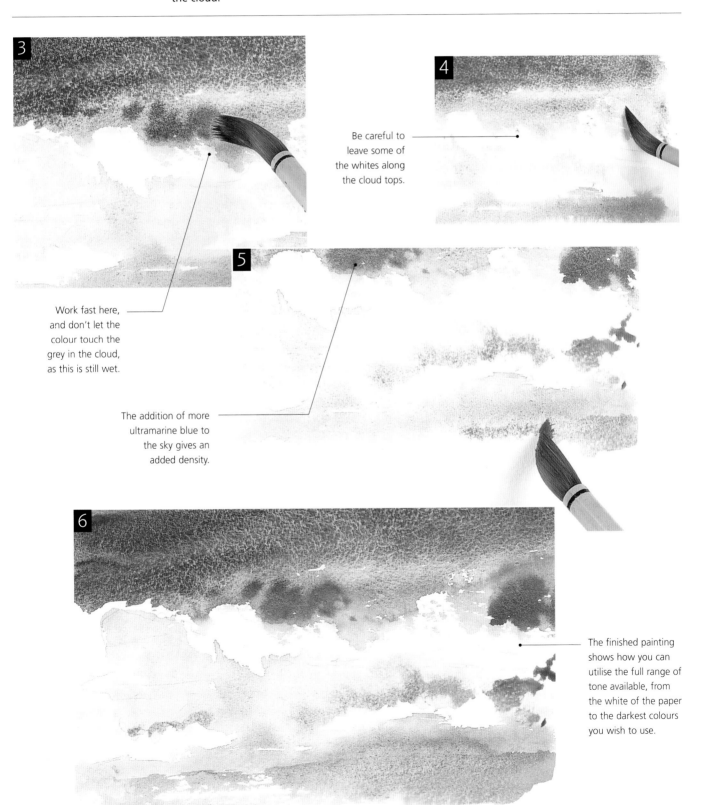

Be careful to leave some of the whites along the cloud tops.

Work fast here, and don't let the colour touch the grey in the cloud, as this is still wet.

The addition of more ultramarine blue to the sky gives an added density.

The finished painting shows how you can utilise the full range of tone available, from the white of the paper to the darkest colours you wish to use.

reserving
whites

materials

Colours: cadmium yellow, ultramarine blue

Watercolour paper:
140 lb cold pressed

Old flat brush

Colour shaper

Masking fluid

Palette consisting of separate pans

Two containers of clean water, one for mixing and diluting your paint and one for rinsing your brush.

22·Masking

Saving smaller amounts of white, or underlying colour, can be achieved easily with masking fluid. It is not suitable for large areas, and not needed for simple shapes. It is most useful when the shape you are painting is relatively complex, for example, a gate. It allows you to paint colour straight across the masked object, which is much easier than painting around it, and when the masking fluid is removed the effect is often better.

Tree trunks in a forest, the bright disk of the sun and foliage in the fore-ground can all be masked to great effect. However, masking fluid can ruin brushes, so other tools are often advisable, and it can rip softer papers so care is needed when removing it. It can be more awkward to model a difficult shape with masking fluid than with a brush and paint, but it is still possible.

1 Apply the masking fluid using a colour shaper. A brush with some soap added can also be used, as this will enable it to be cleaned afterwards.

2 When it is thoroughly dry, mix cadmium yellow and ultramarine blue to form a green, and brush it across.

painting sequence

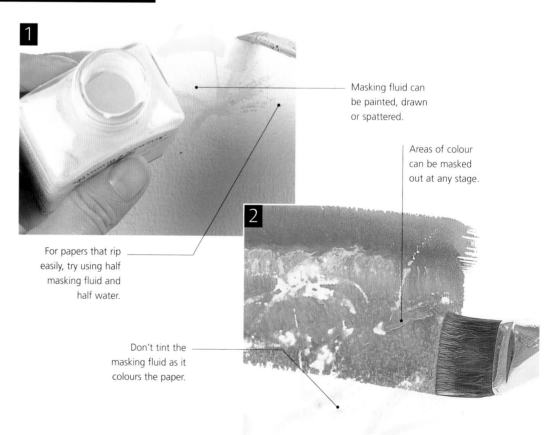

Masking fluid can be painted, drawn or spattered.

Areas of colour can be masked out at any stage.

For papers that rip easily, try using half masking fluid and half water.

Don't tint the masking fluid as it colours the paper.

Strong colour with dense pigment reveals masking the best.

3 Allow the paint to dry thoroughly before attempting to remove the masking fluid. Here it is removed with an eraser.

4 After it is removed a negative image of the masked objects is left as white paper. This can be left white or touched up with colour according to your requirements. You can also mask over colour to protect this from subsequent glazes.

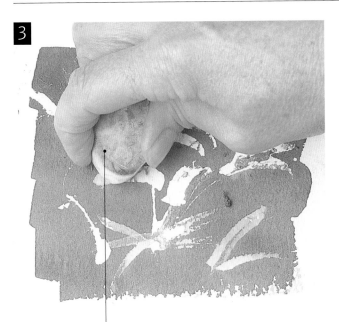

Masking fluid can be removed either with an eraser or with your fingertip. Be careful not to rip the paper.

When removing the masking fluid, some of the pigment will lift with it, leaving a paler version of the original colour on the paper.

using a wax candle

The wax candle technique, or wax resist, can be used to create a speckled light surface on the paper. The texture produced by wax being rubbed on paper is fascinating. It picks up on the surface of the paper, leaving the dimples to absorb subsequent layers of paint. It protects the surface texture, which shines as a rough, fine pattern of light. A wax candle can also protect previously glazed colours.

Here a candle is used to draw a jagged line. Hold the candle firmly and remember that it is difficult to see what you are doing.

The wax candle markings simply appear through the wash.

Use a large flat brush to create a wash of quinacridone red.

23·Granulation

materials

Colours:
alizarin crimson,
manganese blue

Watercolour paper:
140 lb cold pressed

Chinese brush

Palette consisting
of separate pans

**Two containers of
clean water,** one for mixing
and diluting your paint
and one for rinsing
your brush.

With some colours, pigment particles attract each other to produce a grainy effect called granulation. This texture is often very beautiful and can enhance a painting, whether it is used for the mineral effects of masonry or stone, the organic passages of nature or even a blue sky. Viridian, ultramarine blue and cerulean blue will often granulate well.

If the colour name is followed by the word 'hue' on the tube, it may not granulate as well. Granulating colours include cobalt blue, manganese blue, raw sienna and raw umber. Mixing a granulating colour with one that does not granulate will produce an interesting two-colour texture, such as with cerulean blue and alizarin crimson (non-granulating), mixed.

1 Start by brushing a pool of alizarin crimson.

2 Brush an overlapping pool of manganese next to the alizarin crimson.

painting sequence

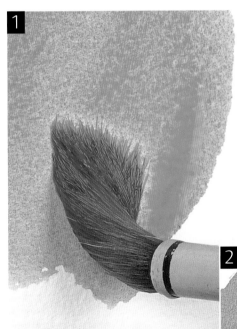

1

For the best effects and maximum granulation, use a rough paper.

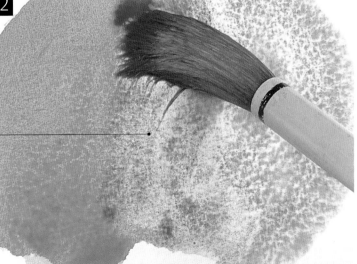

2

Alizarin crimson does not granulate, but note the effects when it is mixed with a granulating colour.

A fairly watery mix will granulate best.

3 Brush a strong mixture of these two colours into the overlap area. Tilt the paper backwards – with the lower part higher, so that granulation occurs in the dimples and pits of the paper texture. Granulation tends to form on the underside of the surface texture. When the painting is hung, shadow in the texture will then enhance granulation.

4 Notice how the manganese granulates and the alizarin crimson does not. In the middle area the violet colour granulates well because it is mixed with manganese.

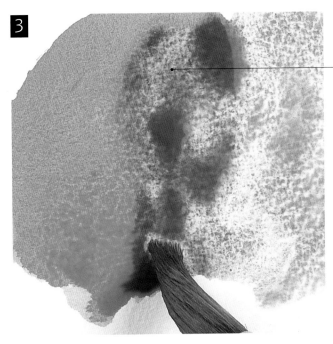

3

Granulation is quite limited in its use, and depends very much on the behaviour of different pigments.

Some colours are more prone to granulation than others. Any manufacturer will advise you about this.

4

granulation fluid

Granulation fluid can be used to make all colours granulate. This medium has been developed to enable the use of non-granulating colours where this texture is desired. It can be used straight or diluted with water.

1

Granulation fluid is resoluble simply by adding water.

Mix some quinacridone gold and some indigo with granulating fluid in a palette.

As the wash dries, the granulation medium encourages granulation to occur in an effect that is otherwise not possible.

3

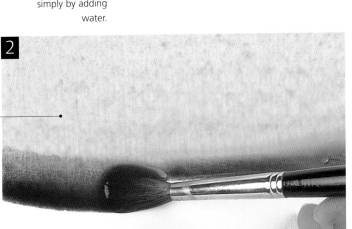

2

Brush quinacridone gold in a wash and paint a little indigo along the bottom. Both of these are non-granulating colours.

special
effects

Colours: ultramarine blue,
cerulean blue

Watercolour paper:
140 lb cold pressed

Hake brush

Palette consisting
of separate pans

**Two containers of
clean water,** one for mixing
and diluting your paint and
one for rinsing
your brush.

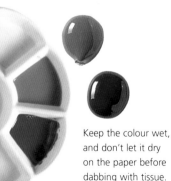

Keep the colour wet,
and don't let it dry
on the paper before
dabbing with tissue.

24·Tissue paper

Tissue paper can be used to remove colour from a damp watercolour painting. It does more than just take the image back to white paper. For example, the kind of shapes it leaves behind are just right for white clouds. This is a common technique for lifting colour.

1 Tear some pieces of tissue paper and crumple them up, keeping them at the ready for the next stage. Make two or three more pieces by twisting the tissue between your thumb and forefinger into long, thin shapes. Paint cerulean blue and ultramarine blue on the watercolour paper to make a sky.

2 Working fast, dab crumpled tissue paper into the sky to remove some of the pigment and to form the soft, fluffy clouds.

3 With each succeeding dab, use a clean side of the tissue or a new piece. The thinner parts of the cloud can be dabbed with the coiled-up twists of tissue.

4 The tissue paper makes the cloud shapes for you, and the result is a convincing band of cloud in a blue sky.

painting sequence

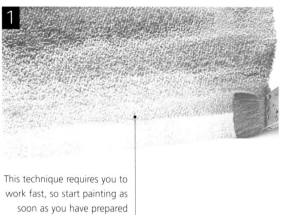

This technique requires you to work fast, so start painting as soon as you have prepared the tissue paper.

Lifting out with tissue paper does not restore the paper to its original pristine whiteness.

Tissue paper creates a soft, indefinite focus to a flat wash.

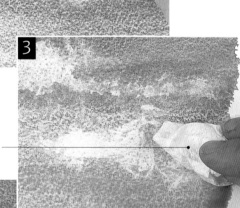

Use a new piece of tissue paper every time you want to remove colour, otherwise the colour will simply be pressed back into the area from which the paint was being lifted out.

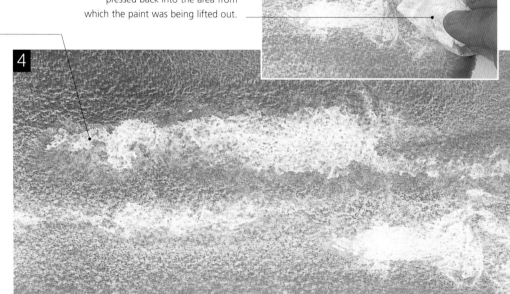

special
effects

25·Sponging

This technique is used as a shortcut to the rapid application of texture. For example, sponging can be a useful means of getting a large mass of texture to simulate a profusion of loose ragged plants in a garden or undergrowth in the wild.

Sponging texture can be used in a variety of settings, perhaps in building up masonry texture for an old building, or the rough appearance of rocky crags. Artists' sponges can be bought, and obtaining several can allow you to dab several different patterns of texture. Alternatively, you can buy a larger bathroom sponge and use its various facets to make the different textures, or rip it up to create a number of smaller sponges, each with a texture of its own.

1 Dampen one half of the paper, leaving the other half dry.

2 Dip the sponge in some permanent green and dab it first onto the damp paper and then onto the dry, observing the textural difference. One is soft focus, the other sharp.

3 Now repeat the process with permanent yellow. When dabbing the pigment onto the paper it is a good idea to rotate the sponge so that you print different textures onto the surface rather than repeating the same one continuously.

4 Wet the right side and leave the left side dry. Dab permanent green over both and see how the texture differs.

materials

Colours: permanent yellow, permanent green

Watercolour paper: 140 lb cold pressed

Sponges: (artists' or bathroom varieties)

Palette consisting of separate pans

Two containers of clean water, one for mixing and diluting your paint and one for rinsing the sponges.

Sponges absorb a lot of colour so plenty of dense pigment needs to be mixed.

painting sequence

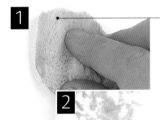

1 Different sponges will create completely different textures on the page.

2

Sponge on dry paper when the crispness of the marks is required.

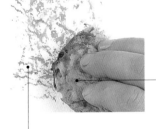

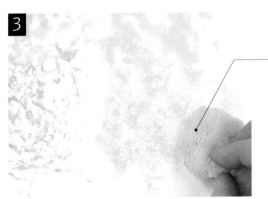

3

Always use a natural sponge as this is more absorbent and pliable, and also creates a pleasing organic pattern.

Marks made with a sponge are not precise enough for intricate work or fine detail.

4

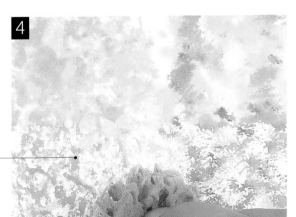

Note how one texture dries to a sharp-edged finish while the other retains softer edges.

special effects

26 · Salt

materials

Colours: phthalo green, cadmium orange

Watercolour paper: 140 lb cold pressed

#8 brush

Sea salt

Palette consisting of separate pans

Two containers of clean water, one for mixing and diluting your paint and one for rinsing your brush.

Sea salt grains dropped onto a wet wash will absorb water from the immediate areas around them. They make little circles of less-damp areas, which draw colour from the wetter surrounding paper. Little star shapes with feathered edges form where the colour has gathered because it could not pass further into the circle of colour which had already dried around each salt grain. The grains speed up the drying process in a tiny area around themselves.

1 Mix phthalo green with cadmium orange to produce a wet wash.

2 Drop some sea salt crystals onto the wet wash. A few star shapes will begin to appear in the colour as this is absorbed by the salt grains. As the paint dries, more star shapes will appear as the water floods out of the crystals and pushes the colour away.

painting sequence

1

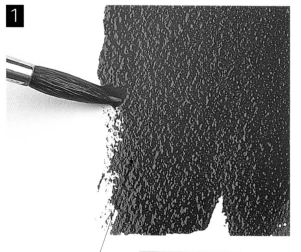

Make sure that the wash is still wet when you drop the salt grains – this effect depends upon the drawing of moisture out of the wash and the absorption of paint and water by the salt.

Salt works to its greatest effect when it is contrasted with areas that have an even finish.

The colour needs to be wet and vibrant here.

2

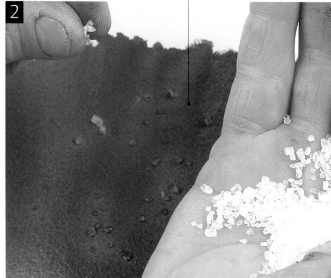

3 The feathered dark edges with feathered ridges of paint in star shapes are now clearly visible. By using large sea salt grains with yellows or oranges, beautiful autumn leaves can be produced.

4 Smaller-grained sea salt produces a finer texture. Here the colour used was cadmium orange.

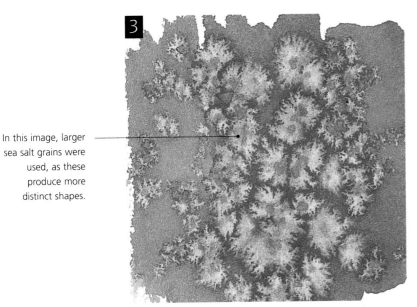

In this image, larger sea salt grains were used, as these produce more distinct shapes.

Being water retentive, salt soaks up the wetness of the paint, then releases it back into the paper as the paint dries, pushing it around each grain to create a star shape.

aluminium foil

Striking effects to create a range of features – twisting ridges and edges, a texture of sharp lines and dark-and-light patches – can be achieved with aluminium foil and cling film.

Apply three broad bands of colour wet on dry, allowing them to blend. Have a crumpled sheet of aluminium foil at the ready.

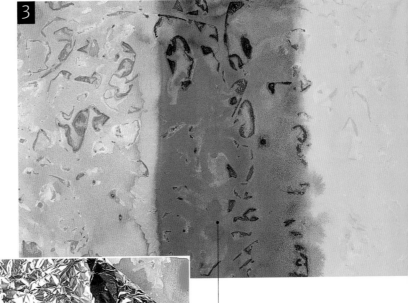

When the paint has dried, remove the foil, and see its texture imprinted onto the page.

Press the sheet of aluminium foil onto the image. Press it gently all around so the crumpled surface is in contact with the still-damp watercolour paint.

special effects

materials

Colours: quinacridone red, ultramarine blue, indigo, cadmium lemon, cobalt turquoise light

Watercolour paper: 140 lb cold pressed

#12 brush

Palette consisting of separate pans

Two containers of clean water, one for mixing and diluting your paint and one for rinsing your brush.

27 · Dropping

Dropping colour onto a wet wash can vary a flat tone, and is a good way of adding colour to textured foliage, to produce a marble effect or to add interest to a range of subjects.

1 Brush a dense wash of quinacridone red onto the paper. With a #12 brush, drop ultramarine blue onto the wet wash of quinacridone red. The brush can be touched onto the surface or droplets can be allowed to fall off from above the paper. Larger droplets are simply made by using more paint, smaller ones by using less.

2 As a variation, a wash of indigo was brushed and opaque colours were dropped onto it. Cadmium lemon and cobalt turquoise light are both lighter than indigo but because of their opacity they make an impression in the darker wash, and push the indigo colour out to form darker ringlets.

painting sequence

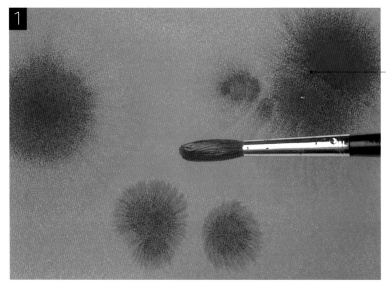

Dropping is a good way of adding surface texture.

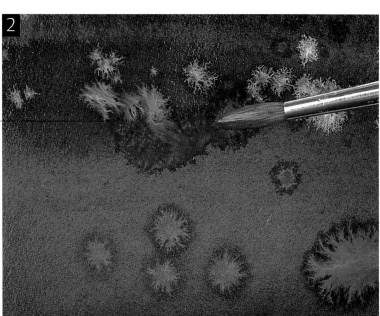

The spots feather out into the surrounding blue, pushing the blue pigment back into 'haloes' of deeper blue around the edges.

Colours need to be rich and wet with a generous loading on the brush, with dense wet washes applied first.

special effects 28·Sgraffito

Sgraffito, or 'scratching out,' can be a precise method of putting a white highlight in a painting. It can be used for a glint of sparkle on water, or, if the flat edge of a blade is dragged along the surface of the paper, the water's surface. Other subjects can include the highlight on the edge of an object when viewing it in the sun, perhaps the edge of a boat or the 'silver lining' of a cloud. The shapes produced by sgraffito generally have to be simple and easily executed.

1 Apply a wash of ultramarine blue and quinacridone red. Let it dry thoroughly. Using a scalpel, apply firm pressure and drag the tip along the paper top to remove the colour. Definitive light lines can be scratched out of a wash.

2 As a variation, paint a wash of cadmium orange and, while it is still wet, drag the scalpel blade along the surface. The blade pulls the colour away from the still-wet wash to leave streaks of white paper showing.

materials

Colours: quinacridone red, ultramarine blue, cadmium orange

Watercolour paper: 140 lb cold pressed

Flat brush

Scalpel or knife

Palette consisting of separate pans

Two containers of clean water, one for mixing and diluting your paint and one for rinsing your brush.

painting sequence

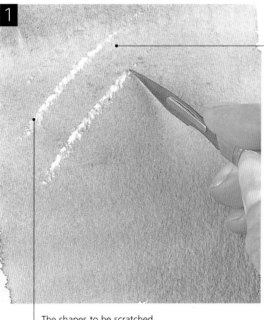

Sgraffito will show up best when there is a strong tone, but it can also be used in light washes for subtle effects.

This alternative used a cadmium orange wash.

The shapes to be scratched out generally need to be simple and easily executed.

Sgraffito tends to be done at the end of a painting when most of the colour is down.

The scalpel blade pulls the colour away from the still-wet wash to leave streaks of white paper showing.

This technique works best with pale watery washes such as for a sunlit sea, as well as strong dense mixes.

29·Ox gall liquid

Ox gall liquid can be used to improve the flow of pigment in washes, and can cause colours to mix very evenly.

materials

Colours: green gold, indigo, permanent rose

Watercolour paper: 140 lb cold pressed

#22 brush

Ox gall liquid

Palette consisting of separate pans

Two containers of clean water, one for mixing and diluting your paint and one for rinsing your brush.

1 Dilute a small amount of indigo poured from a tube onto another palette with ox gall liquid.

2 Paint a flat wash onto dry paper, as with a sky. A #22 brush was used here.

3 Add permanent rose to the base of the sky. Apply with the point of the brush.

painting sequence

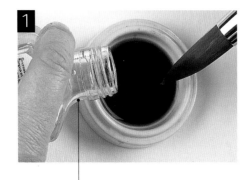

Ox gall liquid should be diluted with around 50 percent water before being mixed with paint.

Note how evenly the pigment spreads.

Ox gall can be useful to eliminate streakiness and achieve a really smooth finish.

Mix the paint with a roughly equal quantity of diluted ox gall liquid.

Let the indigo and permanent rose blend with the other colours for a smooth, ethereal wash.

4 Using the same method, add green gold to the bottom edge of the sky.

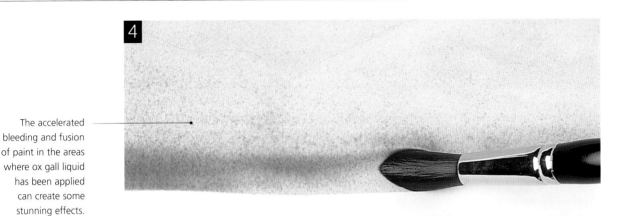

The accelerated bleeding and fusion of paint in the areas where ox gall liquid has been applied can create some stunning effects.

gum arabic

High quality gum is an ingredient of many good watercolour paints. Used in moderation it can reduce the flow of colour and prevent it from blending. Adding a little to a river or to other water scenes in a painting makes the paint sticky like glue, and allows the painting of blurred wet-looking reflections, because marks brushed into the water will not diffuse into the rest of the painting. They will mix slightly, but more or less remain where you paint them, and form blurred wet-looking shapes.

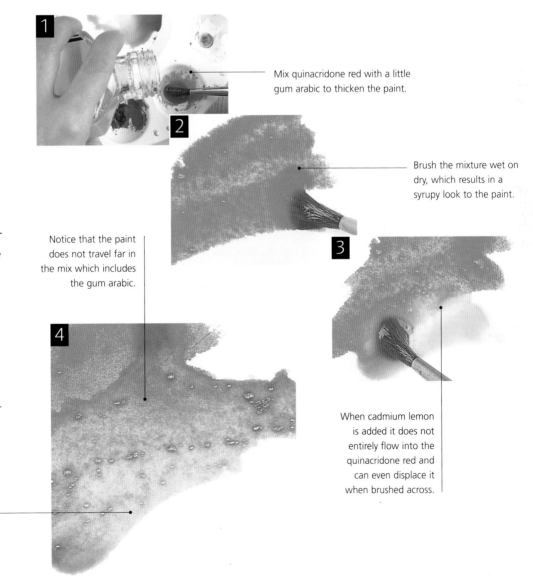

Mix quinacridone red with a little gum arabic to thicken the paint.

Brush the mixture wet on dry, which results in a syrupy look to the paint.

Notice that the paint does not travel far in the mix which includes the gum arabic.

When cadmium lemon is added it does not entirely flow into the quinacridone red and can even displace it when brushed across.

Add a green of ultramarine blue and cadmium lemon.

Projects

This section shows you how professional watercolourists construct their paintings. Analysing their work will give you extra confidence to express your own ideas and make the most of your perfected skills. With more than 20 steps for some demonstrations, the process of creating the painting is presented in bite-sized detail, showing clearly every stage of the painting process.

1·Wild poppies

This demonstration is a wonderful illustration of the watercolourist's art, and uses drawing skills, plus wet-in-wet and wet-on-dry painting techniques. Despite restricting herself to just three colours – the basic primaries of red, yellow and blue – the artist has managed to produce a wide palette of subtle colours.

1 With a pencil, draw in the main outlines of the painting on page 61. A 2B pencil is used here, with a sharp tip to maintain a crisp, fine line. Then apply masking fluid to the stems and hearts of the poppies – these areas will be highlighted later. Leave the masking fluid to dry and quickly wash the brush.

painting sequence

1

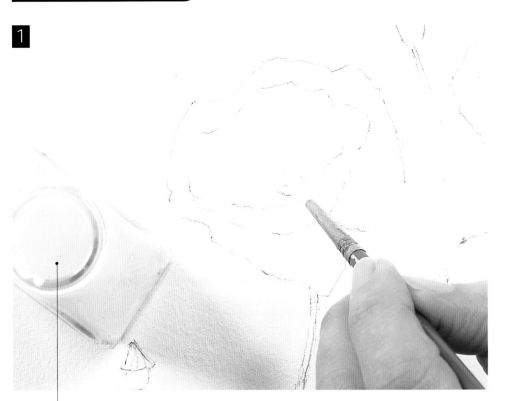

Depending on the brand, the faint colour of the masking fluid will help you see where you have applied it, and later the areas you need to rub to remove it.

2 Using a #12 brush, paint in the main poppy. Mix cadmium red and aureolin yellow to create an orange-red shade for the edge, and use a deeper red for the middle. Then, with a #6 brush, paint the fine veins on the petals, working wet in wet so that the lines soften a little on impact with the petals.

3 Paint aureolin yellow into the background of the rest of the painting, carefully working around the pencilled outlines. Although this should be painted wet on dry, the washes are very wet. Rinse the brush regularly in between applying the different colours.

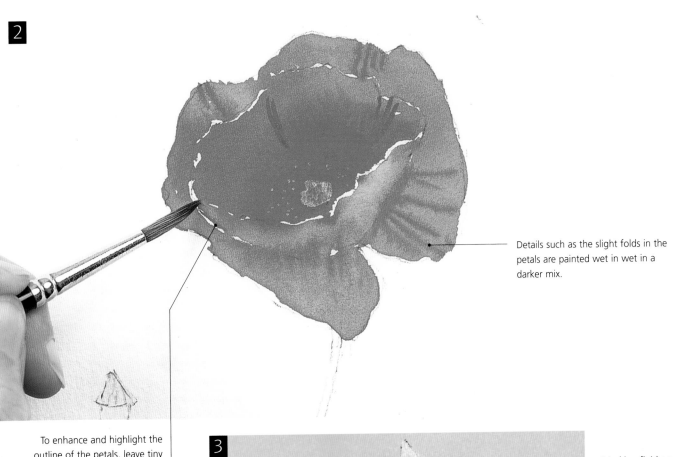

2

Details such as the slight folds in the petals are painted wet in wet in a darker mix.

To enhance and highlight the outline of the petals, leave tiny slivers of white between some of the patches of colour.

3

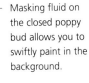

Masking fluid on the closed poppy bud allows you to swiftly paint in the background.

The area round the flower is initially left white. You can then go back and carefully block in the background up to the petal edge.

4 While the background wash is still wet, drop in patches of blue, which will blend with the yellow to make a green. This should be darkest against the outline of the main poppy. Working wet in wet produces soft forms suggestive of shapes in the background.

5 Drop a little red into the background, still working wet in wet. This will mix easily with the base yellow to produce a dark, hazy shade of purple.

6 Flick a few drops of blue onto the wet yellow so that the paint bleeds and creates spots of green.

painting sequence

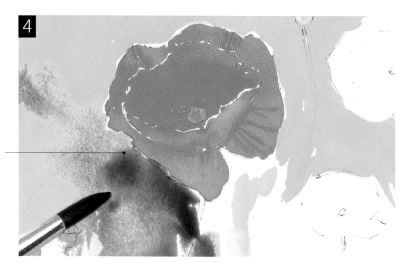

Blue on yellow instantly creates green, providing a gentle contrast for the red of the poppy.

The brush is held at a more acute angle when adding the drops of colour – this allows gravity to help the paint bleed off the brush.

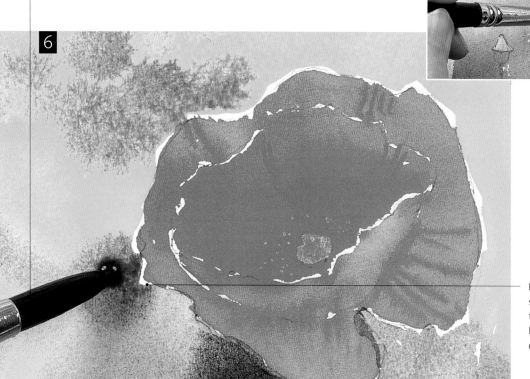

The masking fluid protects the area of the stem from the red paint, allowing you to paint 'behind' the stem in one movement.

Note that the blue should not be taken up to the edge of the petals; leave a little gap to enhance the highlights.

7 Reverse the process from Step 6 now, flicking yellow into the green-blue area to create a misty background. The base colour must still be wet, or the yellow won't mingle. If the paint has dried, it can be re-wetted with clean water. Make sure the paint is applied lightly so that the dry paint pigment does not move around the paper.

8 While the background is still wet, paint in the remaining poppies with a red wash. This will bleed into the yellow to create an orange. Then drop in red for the poppy hearts.

9 Mix a soft green with the blue and yellow from the palette. The green is used to paint in the thinner poppy stems with a #6 brush, then left to dry completely.

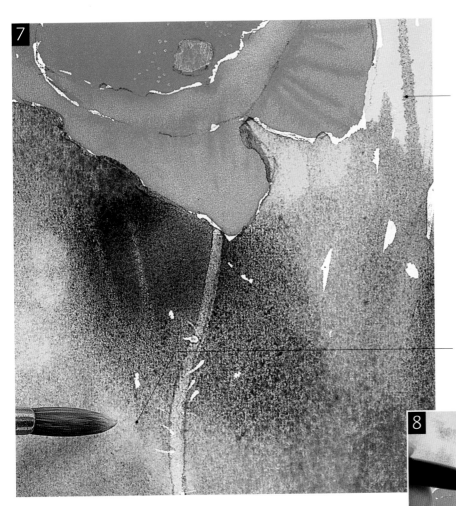

Streaks of blue are painted to look like blades of grass.

Tiny dabs of yellow set off the purple haze below the petals and imitate dappled sunlight.

The paint is applied very lightly to achieve a feathered edge, giving the impression of soft petals.

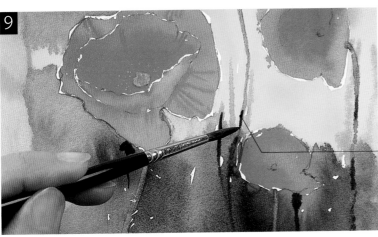

A #6 brush size is essential for achieving the fine lines of the poppy stems. The hand should stay relaxed and move swiftly over the outline.

10 When all the paint is absolutely dry, rub off the masking fluid from the bud, stems and heart of the poppy.

11 Paint the main poppy stem and heart (which were previously masked) using yellow rather than green. Apply a pale green wash to the poppy bud in the background.

12 Using a purple mixed from red and blue, paint in the finer veins and stamens on the heart of the main poppy.

13 Using a strong, deep green wash mixed from blue and yellow, paint some informal leaves and foliage in the foreground. By doing this, the foreground will appear to come forwards, thereby creating a greater sense of depth.

painting sequence

Take care not to rub too hard, or the paper will be damaged.

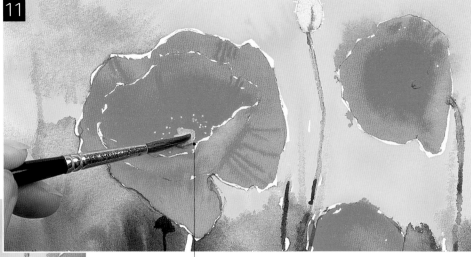

Yellow lifts the highlights of the heart and stamens, and provides some contrast with the red of the petals.

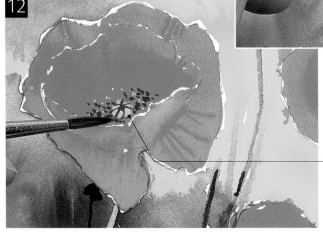

To achieve the finer details of the pod and stamens, they are painted with a wet-on-dry technique.

The hairs on the poppy stem were created by using masking fluid, then rubbing it away. It would otherwise be impossible to keep the paper white when working with the wet-in-wet painting technique.

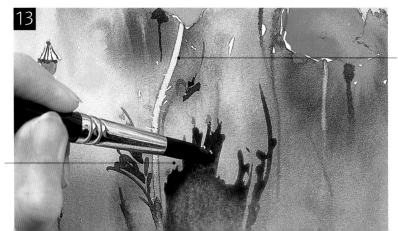

The artist keeps the foliage to a minimum so the poppies are not overshadowed.

The Finished Painting The dark areas lie against the light, and light areas against the dark. This contrast helps to separate and define the forms. Note the contrast in tone between the 'planes' of the painting, growing paler towards the background. These planes are like the wings on a stage set, becoming less detailed and fainter as they recede, creating an illusion of three-dimensional depth.

Wild poppies

by Adelene Fletcher

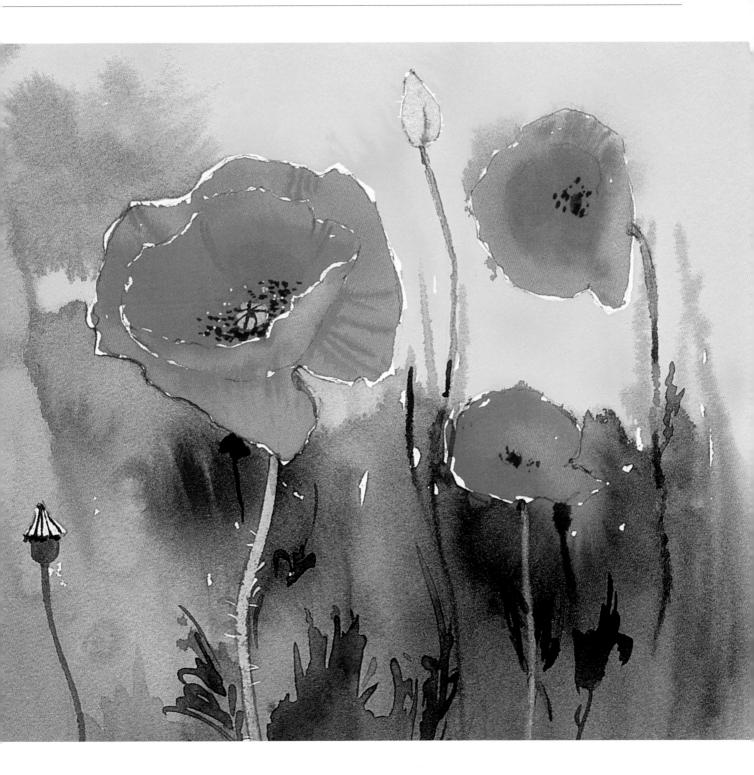

2·Fruit bowl

The joy of still-life painting is that it can be assembled from everyday objects. Because the subject of this kind of painting can be entirely controlled by the artist, as can its arrangement and lighting, still lifes provide an ideal opportunity to experiment with colour and composition. This also means that you can take as much time as you want to work out the composition and prepare the drawing.

1 Sketch the lines of the painting on page 69 on one side of a sheet of tracing paper, and then go over the image on the other side of the same sheet. Place the sketch, right side facing up, on your painting surface and trace the image through, using a 2B pencil. Experiment with the required amount of pressure, and do not press too hard. Using a colour shaper, draw shapes in masking fluid, reserving the light areas of the image. Leave to dry.

painting sequence

1

Mask the leaf shapes where they cross the vase, add detail to the orange and pineapple flesh and add highlights on the figs and the rim of the vase.

After you have finished tracing the image, keep the tracing paper safe for reuse later in the project.

2 Prepare a yellow mix with a generous amount of aureolin yellow and smaller quantities of Hooker's green and ultramarine blue. Make another mix of these colours with more green. Using a #8 brush, wet the paper, avoiding the fruit shapes. Add the yellow mix with a #5 brush, followed by the green mix, working wet in wet. Work the colour around the neck of the vase, holding the brush flat to the paper. This image shows the left side of the vase neck. The negative shape of the vase is left white and defined by the darker colour. The white paper is kept dry and clear of colour.

3 Next apply ultramarine blue to the bowl on the left, wet in wet. The masking fluid on the rim of the bowl will prevent the ultramarine blue from spreading up into the background wash.

4 With a #5 brush, apply streaks of a mix of Bruegel red, aureolin yellow and ultramarine blue. Paint this colour wet in wet into the green background wash. Leave to dry.

5 Wash around the negative spaces of the vase and fruit.

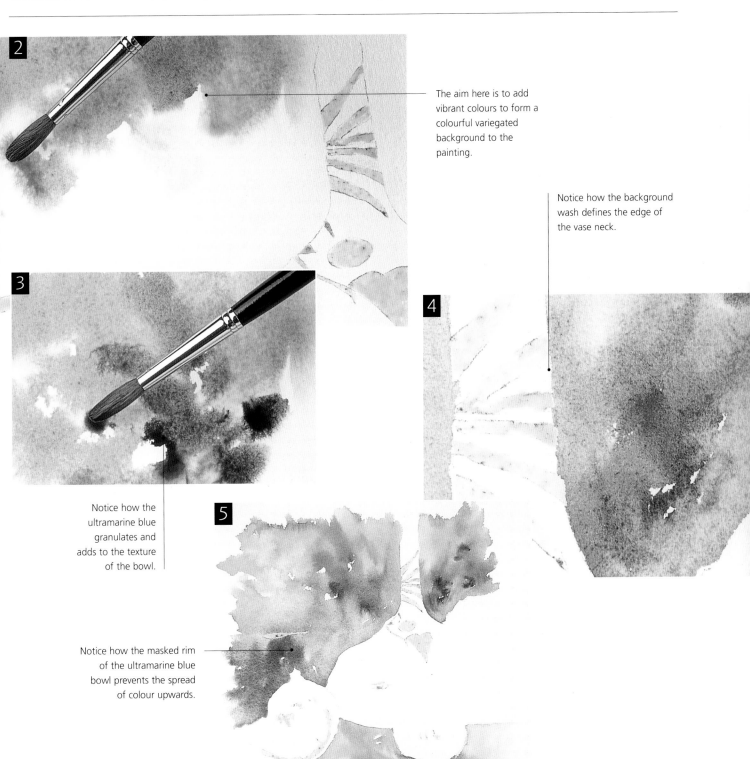

The aim here is to add vibrant colours to form a colourful variegated background to the painting.

Notice how the background wash defines the edge of the vase neck.

Notice how the ultramarine blue granulates and adds to the texture of the bowl.

Notice how the masked rim of the ultramarine blue bowl prevents the spread of colour upwards.

6 Wet the vase neck, keeping small areas dry – these will be saved as white for the vase decoration. With a mix of Bruegel red, aureolin yellow and raw umber, paint the neck of the vase, wet in wet. Then, while the neck is still wet, paint the shadow on the left side of the vase with a mix of Bruegel red, raw umber and ultramarine blue so that it spreads across. Notice the leaves masked across the vase.

7 Using a #4 brush, add aureolin yellow to the orange shape, then brush a mix of aureolin yellow and Bruegel red to make an orange colour, and add this, wet in wet. Leave to dry. Use the orange mix to paint the peel, with wet-on-dry brushwork. Add yellow around masked areas of the orange flesh to highlight the masked whites for later. Brush green around the edge of the fruit inside the skin to highlight the pith.

8 Prepare some permanent rose. With a #8 brush, wash the whole mango with water, then aureolin yellow. While still wet, add a little ultramarine blue into the shadow area with a little more aureolin yellow to deepen the yellow colour.

painting sequence

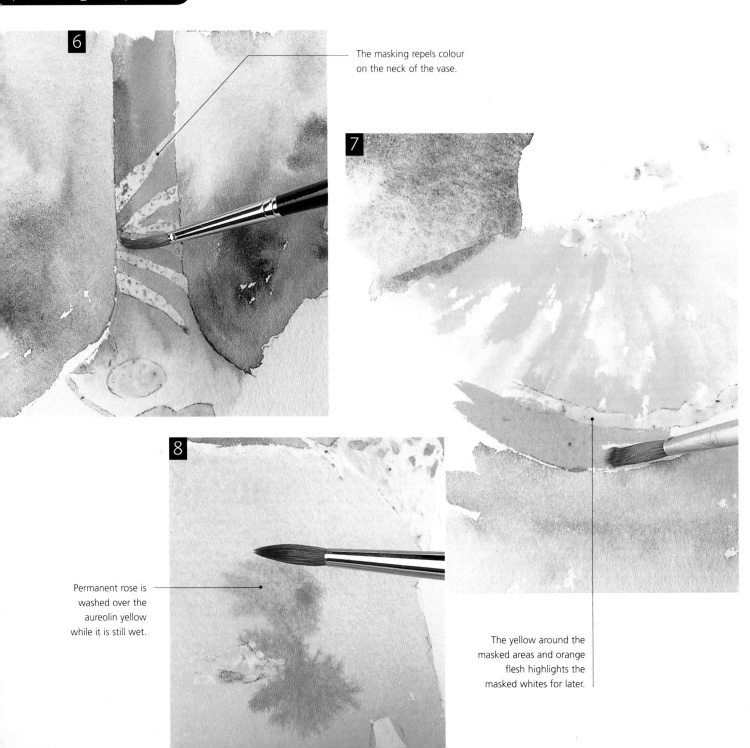

The masking repels colour on the neck of the vase.

Permanent rose is washed over the aureolin yellow while it is still wet.

The yellow around the masked areas and orange flesh highlights the masked whites for later.

9 Using a #8 brush, wash the pineapple with aureolin yellow, wet in wet. While still damp, use the brush to streak water in shapes radiating from the centre.

10 Wet the fig shapes with a #8 brush, and then paint a mix of permanent rose and ultramarine blue, wet in wet. Add lines of permanent rose and ultramarine blue and add a little of the green mixture to the shadow.

11 Retrace the leaves, then work in the negative shapes around them. Apply a little water with a #4 brush and use a #1 brush to apply a similar green mix to the original wash.

12 Keep working the background colours in negative shapes around the leaves.

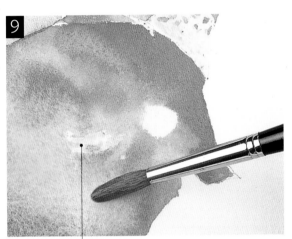

9

Some colour is dabbed out with paper towel, giving shape and texture to the mango shape.

Colour is applied wet in wet for the soft, spreading effect that gives body to the fig.

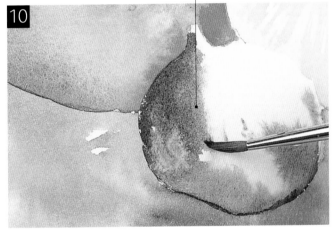

10

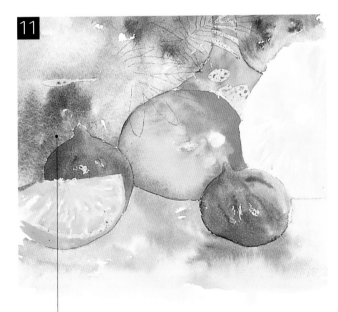

11

The original blue wash of the vase forms a soft edge underneath layered shadows.

Use water to blend the green mix into the original background wash.

The original pencil will have been lost under the colour, so the leaves may have to be retraced.

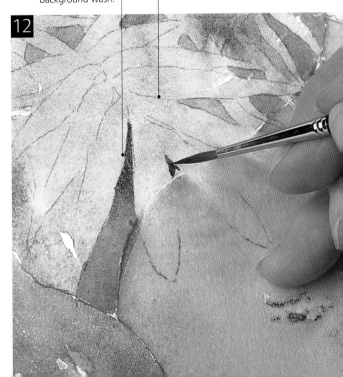

12

13 Paint the leaves over the mango, adding water and aureolin yellow to them. Leave to dry, then add a stronger mix of the green to the aureolin yellow, using #1 and #4 brushes. Apply long brush marks along the length of the mango leaves. Carefully rub out the pencil marks and remove the masking fluid.

14 Brush ultramarine blue onto the bowl, defining the negative shapes of the leaves where they cross it.

15 Use a cotton bud to scratch off paint. Fill in the leaf shapes with a yellow-green version of the green mix. Let in more colour towards the stem with Hooker's green.

painting sequence

After painting aureolin yellow onto the leaves, go over them with green.

The leaves are defined by carefully painting between and around them.

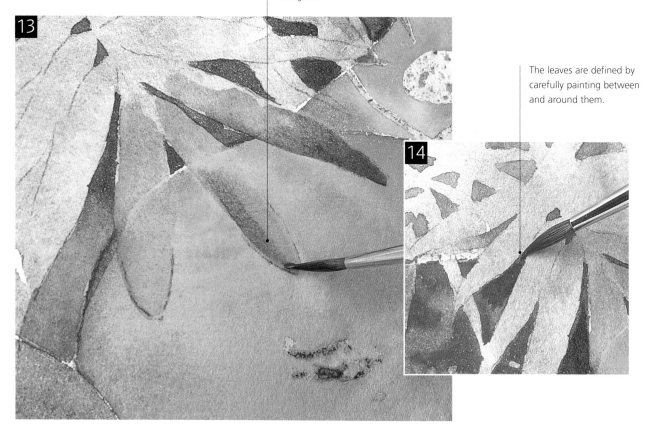

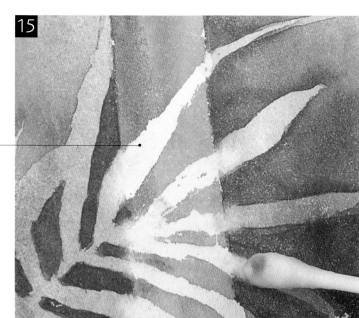

The masking fluid has been removed from the neck of the vase. The edge of the colour – where it crosses the masked leaves – is removed by rubbing with a cotton bud.

16 Use a #1 brush to create veins on the leaves with raw umber added to the green mix.

17 Re-wet the pineapple almost to the outside. Use a #1 brush and a mix of Bruegel red, raw umber and ultramarine blue for the skin. Gently rub the masked highlights on the fig with a damp sponge to create a light area around the bright white.

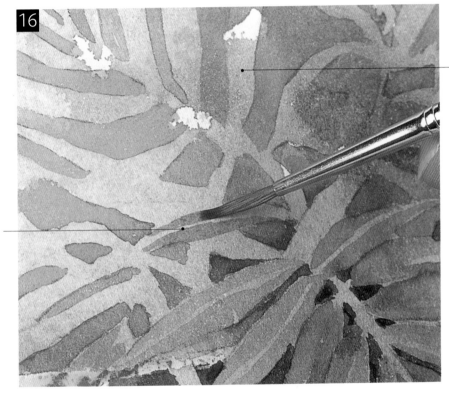

Note how the leaf shapes are constructed by painting around them with positive painting, leaving negative space for the leaves.

Narrow gaps of the underlying colour between the brush marks will be left to represent the lighter-coloured veins.

Negative painting is one way of contrasting highlights and lighter colours.

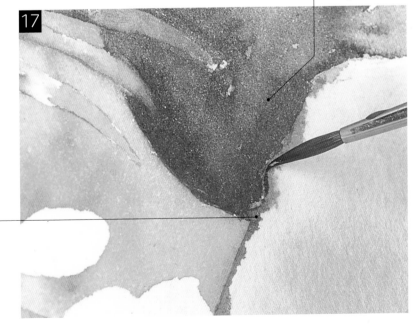

Note how the paint runs into the wet wash on the pineapple in some places, but in others does not touch the wet area and dries to a crisp edge.

18 Wet the table area and, using a #1 brush and a dark mix of Bruegel red, ultramarine blue and raw umber, touch in the shadow under the mango by letting colour in around its form and allowing it to bleed into the tablecloth wash. Use the same method to place shadows under all the fruit on the table.

19 Darken some edges of leaves with the dark green mix. Use the mix of Bruegel red, aureolin yellow and raw umber to finish the vase and define the positive space around the light colour of the pineapple.

20 Make the colour darker with a little more raw umber in the 'V' between the pineapple and the mango. Paint the decorative detail in the saved whites. Paint the stem of the mango with the green mix plus the dark shadow colour mixed together.

21 Using a #1 brush, add the white highlight down the centre of the vase neck with titanium white. Mix a turquoise from ultramarine blue and Hooker's green. Sketch in the shapes of the tablecloth with the turquoise and a #4 brush, leaving out the delicate shapes of the tablecloth pattern.

painting sequence

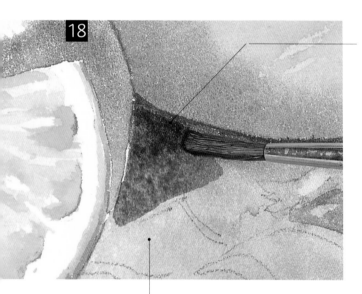

Note how shadow colour defines the lighter masses.

The colour is painted loosely up to the pencil marks to leave a pattern of saved lights of the underlying wash.

The mango leaf is painted by mixing green with the shadow colour, then dragging the pointed brush across the leaf shape, leaving a light vein in the middle untouched.

Use the point of the brush to work colour into the 'V' between the pineapple and the mango.

Opaque colour is brushed on here. Titanium white was applied with a #1 brush to get the shiny highlight on the vase.

The Finished Painting Notice how much of this painting's success lies in its simplicity. The shapes of the fruit and the leaves are complemented by the green tablecloth, which echoes their shape and pattern. Negative and positive spaces are used to create interesting effects, and a fine balance is achieved between crisp detail and the glowing colours.

Fruit bowl

by Julia Rowntree

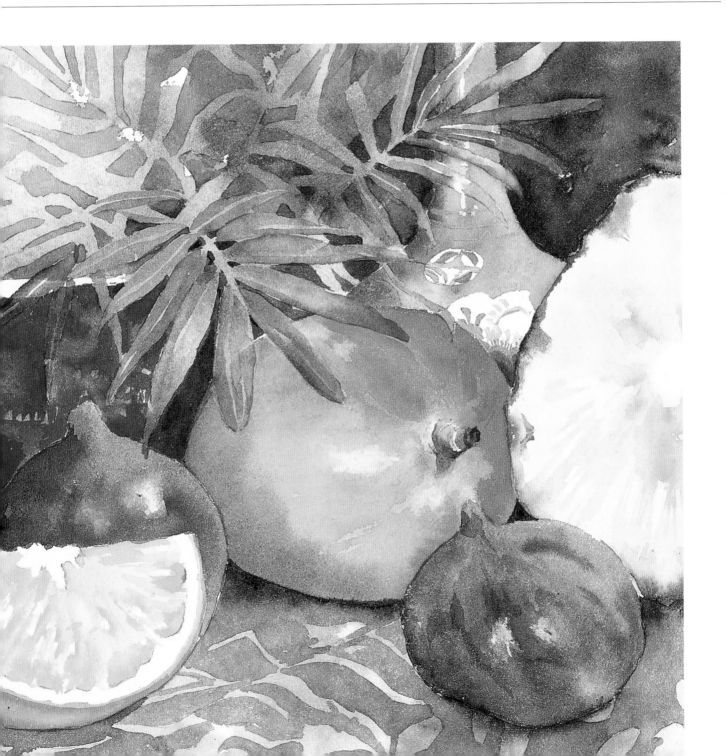

3·Café at noon

materials

Colours: cobalt blue, rose doré, Indian yellow, ultramarine blue, golden green, Hooker's green, cadmium red, dioxazine mauve, turquoise blue deep, burnt sienna, cadmium orange, Prussian blue, light red, burnt umber, brilliant pink, Chinese white

Watercolour paper: 140 lb cold pressed

Brushes: #25 flat, #22 flat, # 4, #1 #22, 5mm (³⁄₁₆") flat

3B pencil

Palette consisting of separate pans

Two containers of clean water, one for mixing and diluting your paint and one for rinsing your six brushes.

Although painting buildings can be a very precise topographical exercise, watercolour is usually more concerned with conveying the overall atmosphere and mood of a particular scene. The pastel colours of this Mediterranean scene offer perfect opportunities to experiment with light, sunny watercolours; the result is suffused by warm light and delicate shades.

1 With a 3B pencil, draw in the main outlines of the painting on page 75. Using a #25 flat brush, or one of similar size and shape, apply a wet-on-dry graded wash of cobalt blue across the top, as far as the outer edge of the building roof.

painting sequence

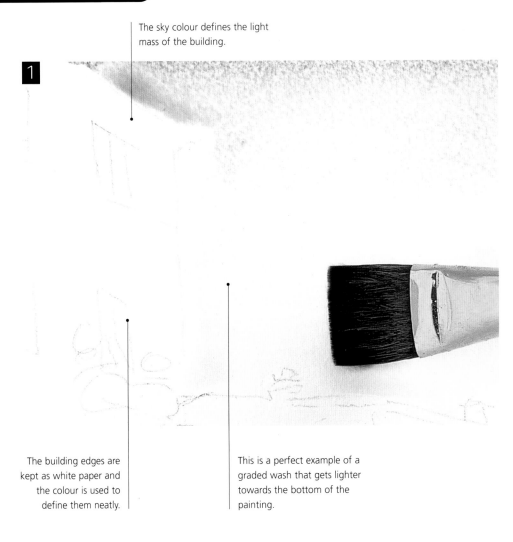

1

The sky colour defines the light mass of the building.

The building edges are kept as white paper and the colour is used to define them neatly.

This is a perfect example of a graded wash that gets lighter towards the bottom of the painting.

2 Using the same brush, apply a wash mix of rose doré and Indian yellow to the building above the canopies. Add a line of ultramarine blue for the canopy shade. Apply this as a wet-on-dry brushstroke using the edge of the flat brush.

3 With a #4 brush and water, selectively wet small areas with dabs of water. Add rose doré, cobalt blue, Indian yellow, golden green and Hooker's green for the foliage. Go for bright transparent colours and prepare them before you start this step. Using the #25 flat brush, apply a mixture of cadmium red and dioxazine mauve, wet in wet, and continue layering the bar area with colour.

4 Using the flat brush again, brush water onto the window apertures.

5 Add turquoise blue deep to the windows, letting the colour spread through the water.

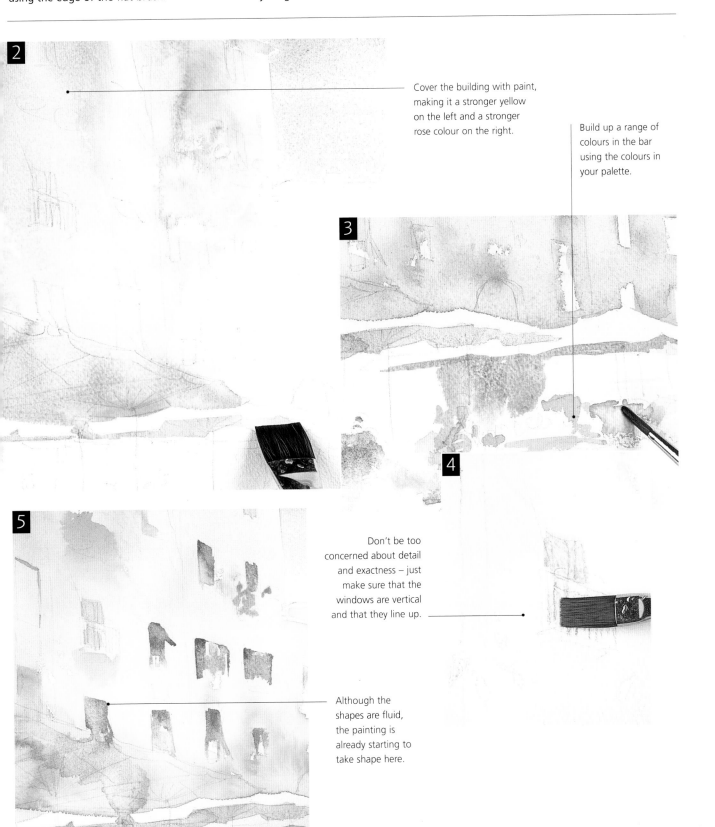

Cover the building with paint, making it a stronger yellow on the left and a stronger rose colour on the right.

Build up a range of colours in the bar using the colours in your palette.

Don't be too concerned about detail and exactness – just make sure that the windows are vertical and that they line up.

Although the shapes are fluid, the painting is already starting to take shape here.

6 Using a #4 brush, blend more turquoise blue deep into the windows before they dry.

7 Wet the areas around the windows and add a warm mixture of burnt sienna and cadmium orange to the building. Continue blending colour in to vary the tone and create texture.

8 Use the tip of a #22 brush to add cadmium red to the windows, working into the wet wash. Keep dabbing in the colour. Add some strong cadmium red to the bar area below. Leave to dry. Wet the triangle shape in the shaded underside of the canopy and add ultramarine blue. Using a large round brush, apply a wash of ultramarine blue with a little light red into the foreground area. Using the tip of a large flat brush, paint linear marks of shadow under the canopies.

painting sequence

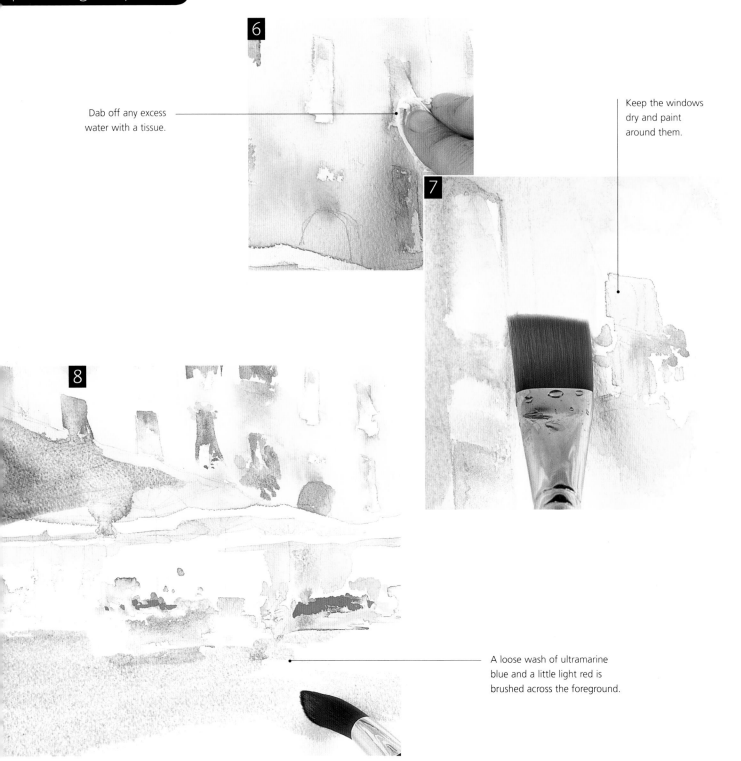

Dab off any excess water with a tissue.

Keep the windows dry and paint around them.

A loose wash of ultramarine blue and a little light red is brushed across the foreground.

9 Use the tip of the flat brush and Prussian blue to define the delicate shadow areas around the tables. While this is still wet, use the tip of a #22 flat brush to blend Hooker's green and a little burnt sienna for the plant pot.

10 Add light red and ultramarine blue to the foreground wash. Create a soft shadow on the ground nearby and make it harder and more defined further away.

11 Using a fine #1 brush, add a dark of burnt umber to create the detail around the flowers.

12 Many colours and tones need to be dotted around for the representation of people, flowers, furniture and shadows. Use the #1 brush with burnt umber to start painting the people.

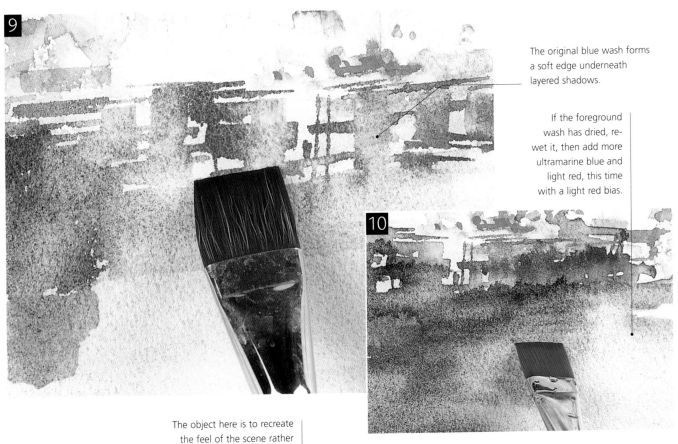

The original blue wash forms a soft edge underneath layered shadows.

If the foreground wash has dried, re-wet it, then add more ultramarine blue and light red, this time with a light red bias.

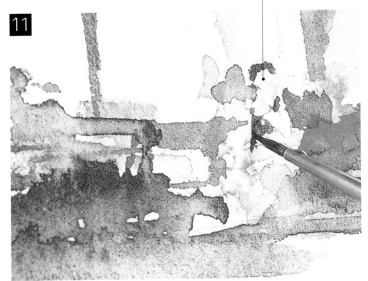

The object here is to recreate the feel of the scene rather than making a highly detailed record.

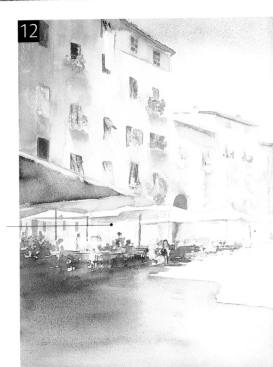

By now there should be a sense of business and activity to the scene.

13 Wet the window apertures and add some Prussian blue with a #1 brush. Add brilliant pink and cadmium red for the flowers, and Hooker's green and golden green for the plants. Paint burnt sienna and a little burnt umber for the shadow and the lighter canopies to the right. When dry, brush a wash of burnt umber and ultramarine blue for the shadow under the darker canopy. With a #4 brush, paint Hooker's green around the people. When dry, add a little pink for the people.

14 Use the edge of a flat brush to add structure to the umbrella with burnt umber and ultramarine blue in a strong mix. Continue adding detail into the canopy in the foreground using a 5mm (³⁄₁₆") flat brush. Use Indian yellow to apply definition at different angles around the umbrellas.

15 Paint the plant pot on the left with light red and burnt sienna. Use a flat brush at different angles to apply a light red and ultramarine blue mixture to the tables.

16 Add some people on the right using burnt umber. Add pink for their faces when dry.

painting sequence

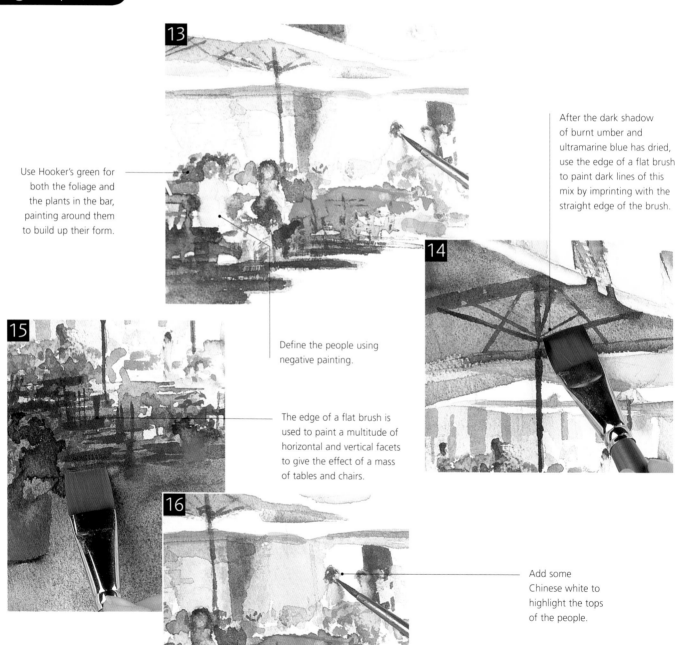

Use Hooker's green for both the foliage and the plants in the bar, painting around them to build up their form.

After the dark shadow of burnt umber and ultramarine blue has dried, use the edge of a flat brush to paint dark lines of this mix by imprinting with the straight edge of the brush.

Define the people using negative painting.

The edge of a flat brush is used to paint a multitude of horizontal and vertical facets to give the effect of a mass of tables and chairs.

Add some Chinese white to highlight the tops of the people.

The Finished Painting The mood and atmosphere of a sunny Italian café is perfectly captured here. Light and shade are cleverly handled, with the pastel colours of the building providing a pleasing contrast to the shadow of the café area. The almost Impressionistic effect of detail in the café is perfect for the watercolour medium, as are the broad washes of the buildings and sky, giving a feeling of space and height to the painting.

Café at noon

by Glynnis Barnes Mellish

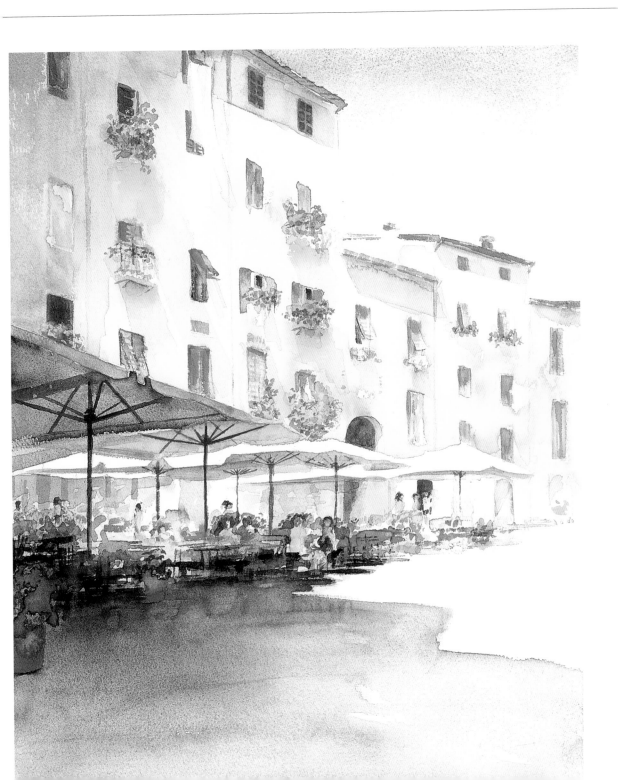

4·Reading in the sun

This is an example that epitomizes the watercolourist's art – the painting could not have been created in any other medium. A sketchy and Impressionistic treatment of a subject can be preferable to an overworked oil painting, and the depiction of this summer scene has a freshness and almost transparent light. This gives the sense that the artist has caught a very precise moment on paper.

Colours: turquoise blue deep, purple dioxazine, yellow ochre, alizarin crimson, Hooker's green, cobalt blue, golden green, ultramarine blue, burnt sienna, light red, burnt umber, ultramarine violet, cadmium red

Watercolour paper: 140 lb cold pressed

Brushes: #2 filbert, #22 round,#2, # 4, 5mm (³⁄₁₆") flat

3B pencil

Candle

Paper towels

Palette consisting of separate pans

Two containers of clean water, one for mixing and diluting your paint and one for rinsing your five brushes.

1 With a 3B pencil, draw in the main outlines of the painting on page 83. Add water to the paper and brush in purple dioxazine for the background flower colour. Add turquoise blue deep for distant colour and golden green for sunlit foliage. Paint loose swaths of colour with a #22 filbert brush to prepare the ground for the painting. Add water to the shape of the figure, then add diluted yellow ochre to the paper and paint alizarin crimson for the flesh colour.

painting sequence

1

The paper is not pre-stretched, so it buckles when wet, but this can help to create interesting textures as the water collects and moves around.

Simple batches of colour are often loosely brushed on to lay the foundation for a watercolour painting. These are used to start to define shapes, but not to complete them.

2 Use a #22 round brush and drybrush a Hooker's green and cobalt blue mix under the figure and on the foliage to the right.

3 Work over the Hooker's green, wet in wet, with golden green.

4 With a #4 brush, paint golden green onto the image. Make some leaf shapes and draw around the purple dioxazine blooms, defining their negative shapes with positive painting.

Use a #22 brush to make really big, broad strokes of Hooker's green and then golden green.

See how smooth the flesh colour is. This is because the yellow ochre and alizarin crimson colours were painted into a wash of water, and then left to blend and spread without further interference.

Loosely brush golden green onto the image here, defining the slats of the chairs by painting around them.

5 Using a #22 brush, apply a mix of alizarin crimson and golden green on the ground. Add ultramarine blue, wet in wet, across the bottom.

6 Work a violet blue shadow colour of alizarin crimson and ultramarine blue with a little golden green into the shadow on the arm and below, and the shorts.

7 Don't just concentrate on one area, but work all over the image with each stage.

painting sequence

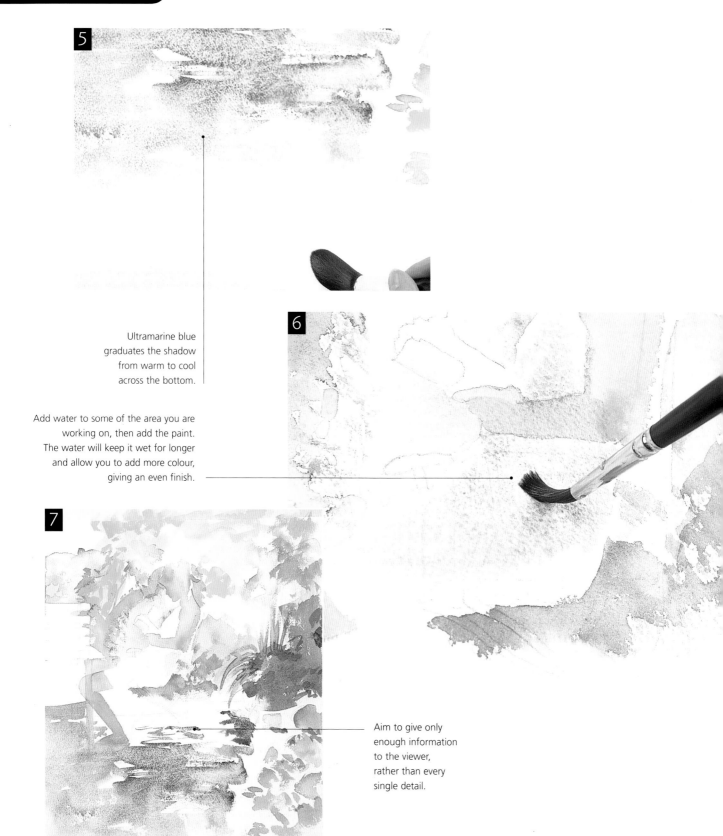

Ultramarine blue graduates the shadow from warm to cool across the bottom.

Add water to some of the area you are working on, then add the paint. The water will keep it wet for longer and allow you to add more colour, giving an even finish.

Aim to give only enough information to the viewer, rather than every single detail.

8 Add burnt sienna to the step behind the girl and then blot with a piece of paper towel.

9 Create a wax resist for the texture of the foliage by rubbing a candle on the image. Paint over the waxed area with a strong mix of Hooker's green.

10 Apply a light burnt sienna shadow to the girl's face. Brush the hair with pale yellow ochre, wet in wet, then brush in a few further streaks of the same colour. Wet the ear shape up to the inside of the ear rim. Apply colour along this edge, producing a lost-and-found edge.

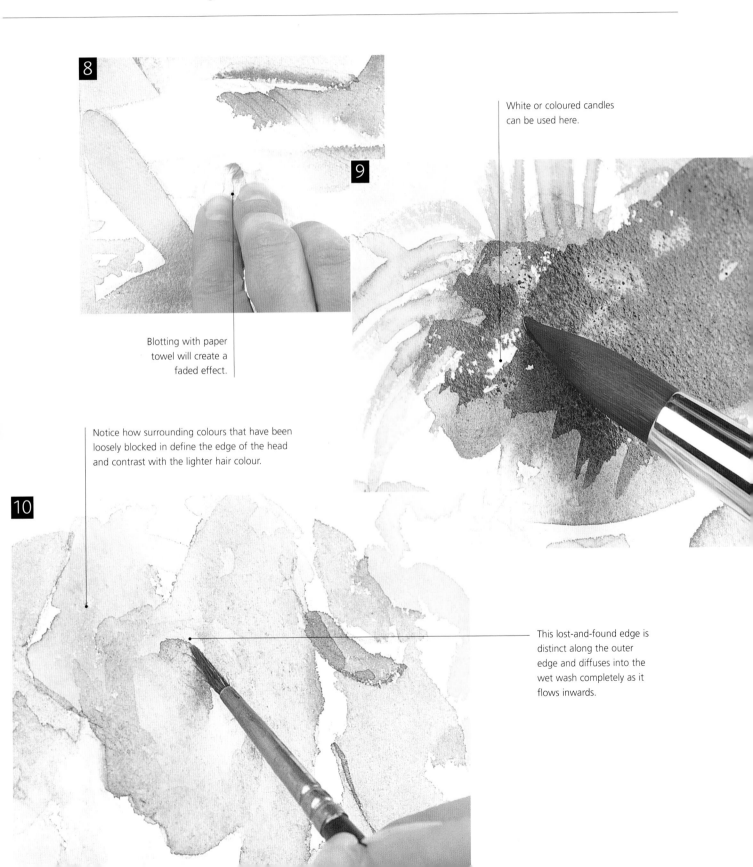

White or coloured candles can be used here.

Blotting with paper towel will create a faded effect.

Notice how surrounding colours that have been loosely blocked in define the edge of the head and contrast with the lighter hair colour.

This lost-and-found edge is distinct along the outer edge and diffuses into the wet wash completely as it flows inwards.

11 Mix a grey with ultramarine blue and a little light red. Paint the cat a light grey and colour the paws and ears light red, similar in tone to the girl's face.

12 Use a flat brush to paint the chair and chair back slats with a grey mix of purple dioxazine, a little ultramarine blue and a little light red.

13 Use the point of a #4 brush to apply a mix of burnt umber, ultramarine blue and Hooker's green to the chair in lines.

painting sequence

The cat's ears and paws should be similar in tone to the girl's face.

A flat brush can be used to render the slats with a single stroke for each one.

Build up the colour here with several layers, drying it before successive applications.

14 Mix a dark from purple dioxazine and burnt umber. Using the #4 brush, spatter the paint over the foliage.

15 Using the dark of purple dioxazine and burnt umber, build up definition with a #22 round brush.

16 Using a 5mm (³⁄₁₆") flat brush, paint the book with golden green and ultramarine violet. Using ultramarine violet, paint the stripes on the dress. Wet the leg, adding a mixture of cadmium red and purple dioxazine to deepen the colour – more violet lower down in the shade, and redder further up.

17 Using a #22 brush, keep layering more foliage with the dark purple mix of dioxazine and burnt umber, adding a few leaf shapes to the edges.

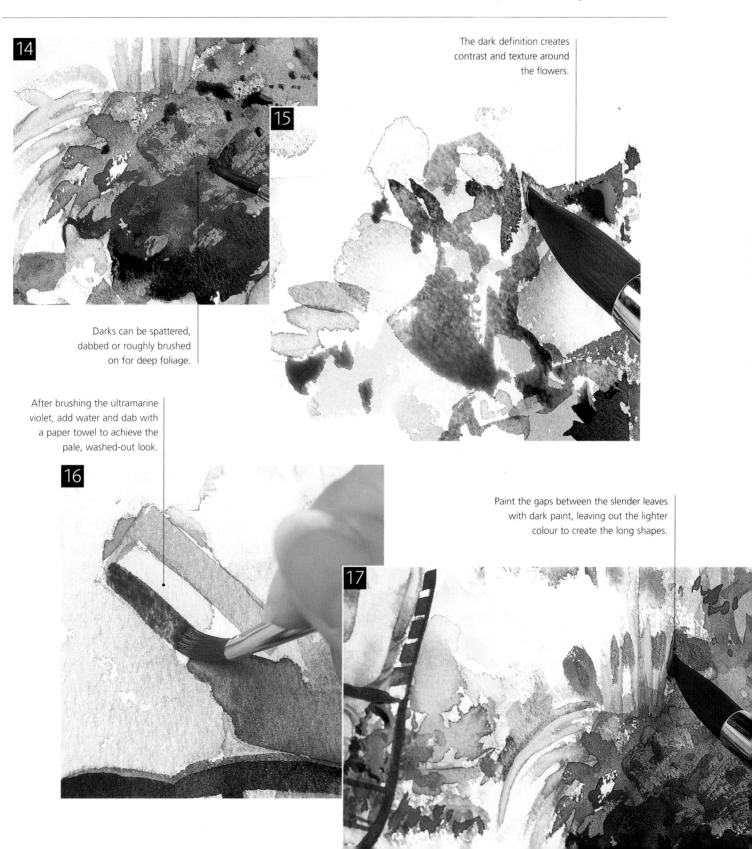

The dark definition creates contrast and texture around the flowers.

Darks can be spattered, dabbed or roughly brushed on for deep foliage.

After brushing the ultramarine violet, add water and dab with a paper towel to achieve the pale, washed-out look.

Paint the gaps between the slender leaves with dark paint, leaving out the lighter colour to create the long shapes.

18 Wet the face and add a little yellow ochre, applying alizarin crimson on top for the flesh colour.

19 Use light red to add some intense colour to the face to create definition. When the eyelid is dry, touch in an eyelash with a dark of light red and ultramarine blue.

20 Brush some strands of hair with a mix of burnt umber and yellow ochre, wet on dry, using a 5mm (³⁄₁₆") flat brush.

21 Using a #4 brush, apply water to the arm. Use a mixture of purple dioxazine and light red with a little ultramarine blue, and add this wet in wet on the arm. Vary the colours, adding blue in places and red in others. Keep the sunlit upper arm light. Using a 5mm (³⁄₁₆") flat brush, paint the book with green gold and ultramarine violet.

painting sequence

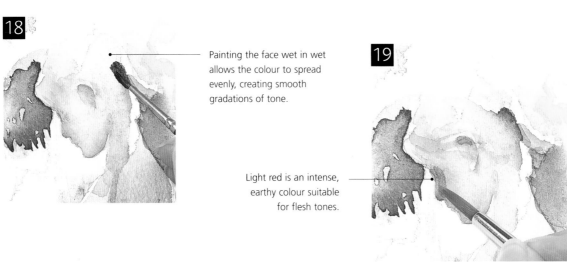

18 Painting the face wet in wet allows the colour to spread evenly, creating smooth gradations of tone.

19 Light red is an intense, earthy colour suitable for flesh tones.

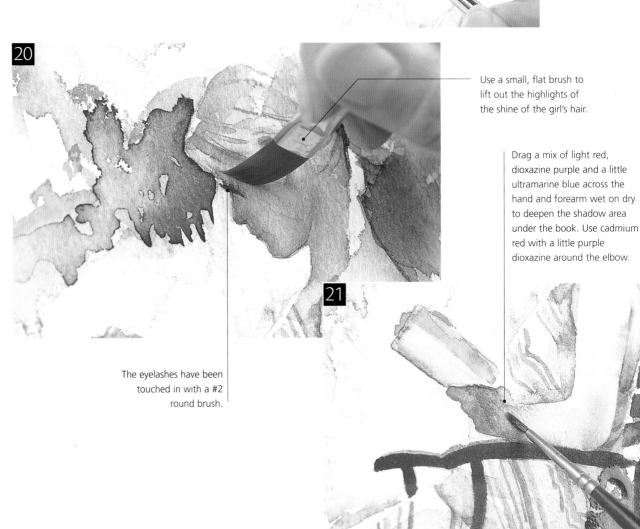

20 Use a small, flat brush to lift out the highlights of the shine of the girl's hair.

Drag a mix of light red, dioxazine purple and a little ultramarine blue across the hand and forearm wet on dry to deepen the shadow area under the book. Use cadmium red with a little purple dioxazine around the elbow.

The eyelashes have been touched in with a #2 round brush.

21

The Finished Painting The beauty of this finished piece lies in the spontaneity of style. Enough information is given about the subject to engage the viewer, but the artist has allowed her imagination to really come to the fore here. The painting is more about shapes and colours than it is about the detail of individual objects. The interplay of the cool blues and mauves with the warmer yellow in the background gives a sense of perspective and depth to the painting.

Reading in the sun

by Glynnis Barnes Mellish

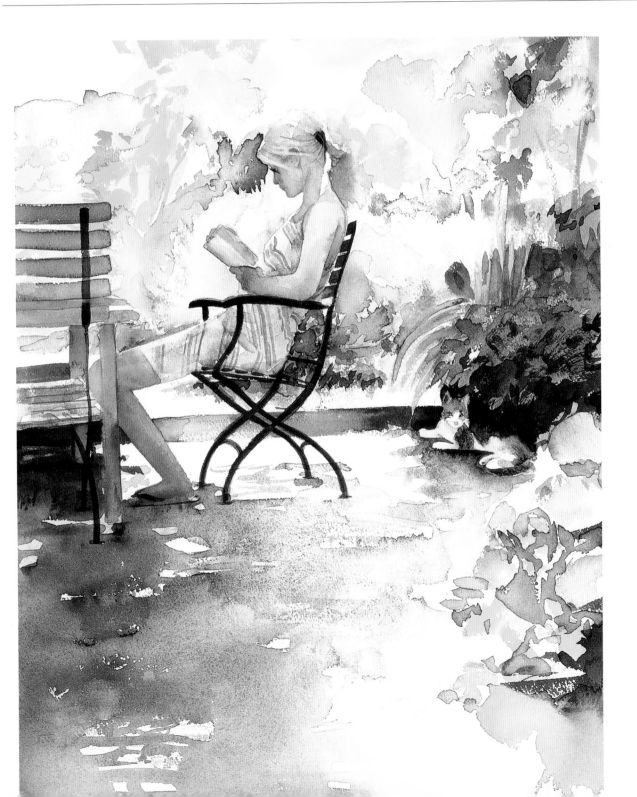

5·Parrot in wild thicket

materials

Colours: Hooker's green, phthalo blue, cadmium lemon, burnt sienna, burnt umber, lamp black, cadmium red, alizarin crimson, purple madder, ultramarine blue, cerulean blue, Prussian blue, bright red

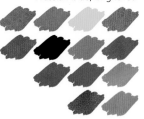

Watercolour paper: 140 lb cold pressed

Brushes: Old sable brush, #16 flat hog's-hair, Chinese brush

3B pencil

Palette knife

Water spray
Masking fluid

Paper towels

Palette consisting of separate pans

Two containers of clean water, one for mixing and diluting your paint and one for rinsing your three brushes.

Clearly one problem with drawing animals is finding an object that will keep still for an extended length of time. Because of this, it is often easier to use a photograph as a reference than to attempt to paint on location. This also has the obvious advantage of extending the scope and range of the subject matter.

1 With a 2B pencil, sketch the parrot shown in the painting on page 89. Using an old #2 sable brush, apply masking fluid to the beak, around the eye area and in the feathers.

2 Also mask out some leaves using the finished picture as a reference. Dry all areas with a hairdryer. Clean the brush immediately after use.

shown in the painting on page 89.

painting sequence

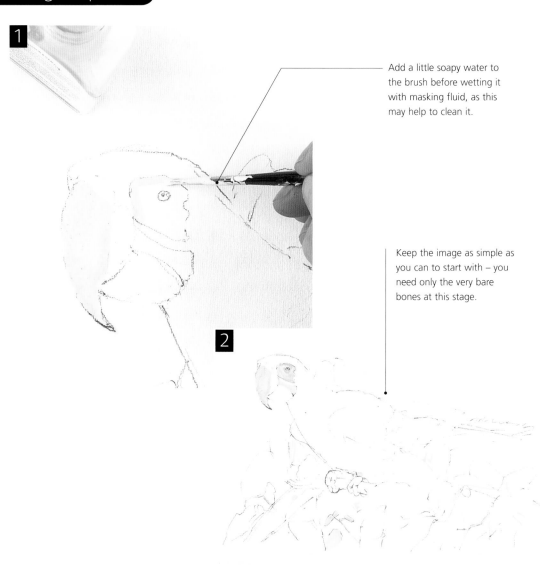

Add a little soapy water to the brush before wetting it with masking fluid, as this may help to clean it.

Keep the image as simple as you can to start with – you need only the very bare bones at this stage.

3 A lot has to be done while the image is still wet – so prepare now. You will need a large flat hog's-hair brush – a #16 was used here. Prepare some phthalo blue, Hooker's green, cadmium lemon and burnt sienna, and have a palette knife ready. A small water spray is an easy way of gently applying water. Use the hog's-hair brush to apply a thin wash of phthalo blue to the paper wet in wet. Keep the parrot dry – this area must remain a saved white until later.

4 While it's still wet, add Hooker's green to the wash all around the parrot. Add cadmium lemon and burnt sienna to the wash, wet in wet, for an interesting, variegated wash. Use the large hog's-hair brush and work it up until there is a dense mix of colours on the paper.

5 Dry with a hairdryer and add more Hooker's green, cadmium lemon and burnt sienna. The additional passages have sharply focused edges. You can define the form by painting around it, leaving in shapes and leaving colour out.

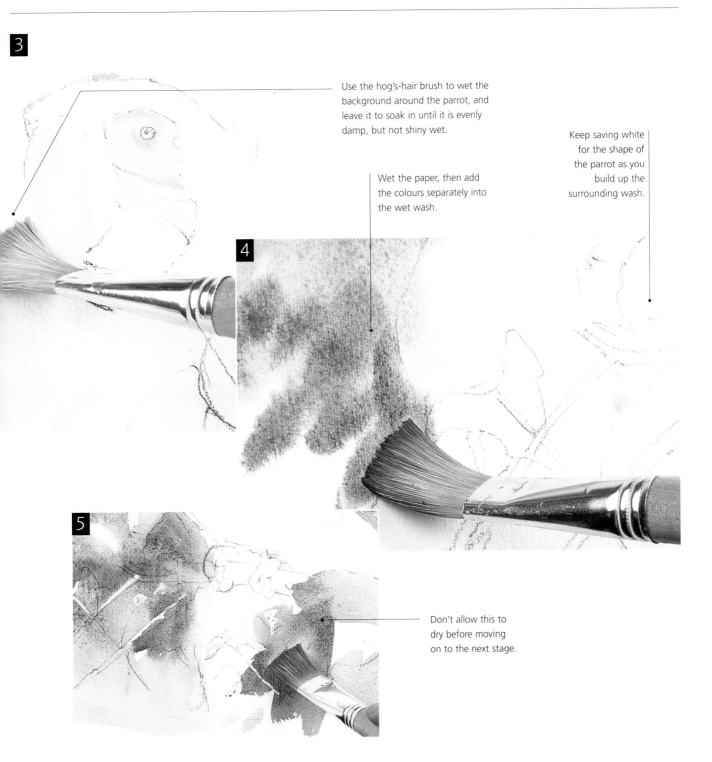

3

Use the hog's-hair brush to wet the background around the parrot, and leave it to soak in until it is evenly damp, but not shiny wet.

Keep saving white for the shape of the parrot as you build up the surrounding wash.

4

Wet the paper, then add the colours separately into the wet wash.

5

Don't allow this to dry before moving on to the next stage.

6 While the wash is still damp, but not soaking wet, use the palette knife to scratch out light veins on the leaves. Use a Chinese brush to apply Hooker's green around and between the leaves, using this positive space to define the negative shapes.

7 Use the water spray to soften the paint a little by spraying a little clean water over the foliage area.

8 Use a smaller palette knife to create the fine veins on some of the leaves. Model the shapes of the leaves by painting dark between them, and leaving their forms as the lighter, underlying wash.

9 Work on the dark area of wood and foliage texture beneath the parrot. Add a thick layer of colour, saving white for the parrot's feet, but covering the branch. Use burnt umber with a tiny amount of lamp black. Now press a piece of paper towel firmly against the colour and remove. Immediately use the spray to form delicate droplets on the surface of the damp paint.

painting sequence

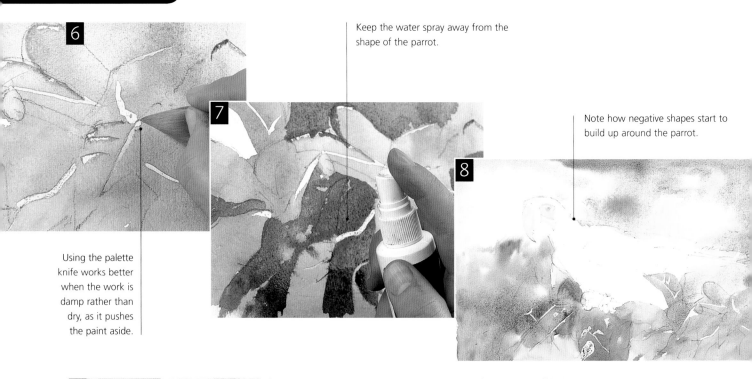

Keep the water spray away from the shape of the parrot.

Note how negative shapes start to build up around the parrot.

Using the palette knife works better when the work is damp rather than dry, as it pushes the paint aside.

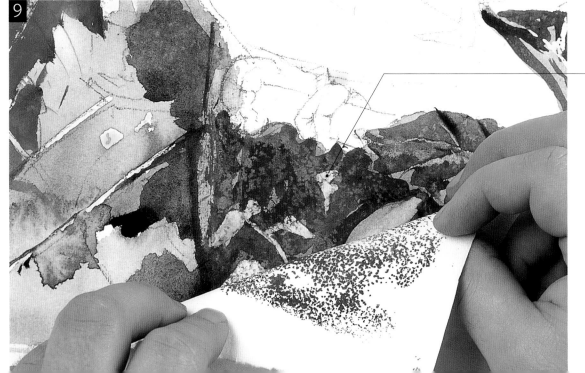

Spattering can also be used to create a similar effect here.

10 To complete the mass of foliage, apply Hooker's green to create the light sides of the leaves, and add cadmium lemon, wet in wet, to create the transition in colour. Add burnt umber down the other side, as with the leaf shown, to create a darker side. Paint the other leaves in the same way. Use the knife to create a few more highlights while it is still damp. Dry with a hairdryer.

11 Mix some cadmium red with alizarin crimson to make a deep red. Using a Chinese brush, build this colour onto the parrot and then apply some cadmium red on its own.

12 Mix some cadmium red with purple madder to create a brownish purple. Use this to paint delicate darks with the Chinese brush, including the neck and the parrot's feet on the branch.

13 Create the soft edge of the parrot's tail by using a damp hog's-hair brush to soften the wash of colour around its shape. Keep the area damp and add some of the cadmium red and alizarin crimson mix, letting it spread outwards along the soft-focus feathers.

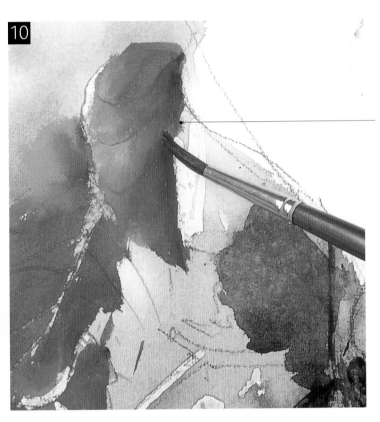

10

Let the colours blend at the join.

Use the colour boldly here to achieve a really vibrant shade.

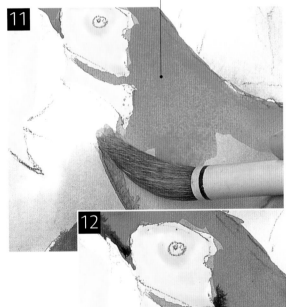

11

12

You can achieve the soft edge of the feathers by softening the colour with a clean, damp hog's-hair brush.

13

You can also create this colour using ultramarine blue and burnt umber.

14 Add Hooker's green to the feathers, wet in wet, then blend in some cadmium lemon.

15 Add cerulean blue and Prussian blue for the darker feathers, and Prussian blue with alizarin crimson for the shadow under the feathers.

16 Scratch some of the feathers with a palette knife to create the 'ribbing'. Dry with a hairdryer and rub off the masking fluid. Continue layering paint with the cadmium red and alizarin crimson mixture. Before it dries, scratch more knife markings.

17 Wet the upper beak, keeping the edges dry. Mix purple madder into the cadmium red and alizarin crimson mix, and then pull in streaks across the lower beak, to make the markings on top of the beak. Dry, then paint the dark line around the beak.

18 Paint burnt umber on the branch, and brush some darker lines along it, wet in wet. Brush some darks for the lines on the parrot's claws. Dry, and scratch some light lines on the dry claws with a scalpel for fine whites. Make a few more markings around the feathers and leaves.

painting sequence

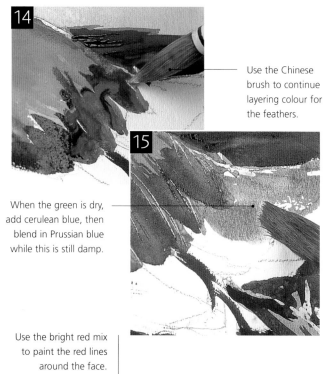

14

Use the Chinese brush to continue layering colour for the feathers.

15

When the green is dry, add cerulean blue, then blend in Prussian blue while this is still damp.

Use the bright red mix to paint the red lines around the face.

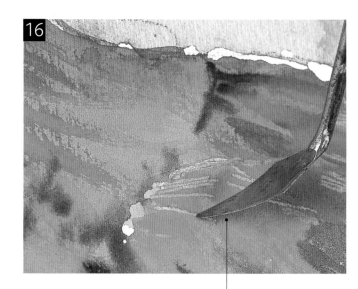

16

Scratch the markings on the feathers before the paint has dried.

Brush dark lines around the parrot's claws. When dry, scratch light lines in the same direction with a scalpel.

17

18

The Finished Painting Some people think of watercolour as being subtle, delicately transparent and pastel-like, but this is an example of vivid glowing colours. Here, brushwork is carried out with almost pure paint. The complementary colours of red and green, and to a lesser extent blue and yellow, increase the impact of the painting.

Parrot in wild thicket

by Mark Topham

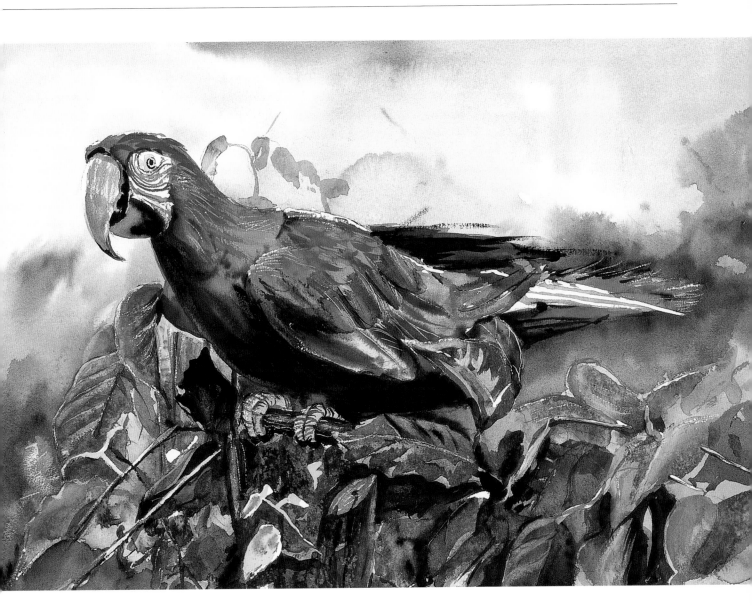

6·Family portrait

Although not a traditional medium for portrait painting, watercolour can be ideal to depict the living, organic features of hair, eyes and skin. Careful planning at the outset is essential, however, as it can take only one misplaced feature to unbalance the whole picture.

materials

Colours: yellow ochre, alizarin crimson, cobalt blue, quinacridone gold, Hooker's green, ultramarine blue, light red, cadmium orange, burnt umber, phthalo blue, viridian

Watercolour paper: 140 lb cold pressed

Brushes: #22 flat, # 2, #6, 5mm (³⁄₁₆") flat

3B pencil

Paper towels

Palette consisting of separate pans

Two containers of clean water, one for mixing and diluting your paint and one for rinsing your four brushes.

1 Using a 3B pencil, sketch the group portrait on page 97 on your paper. Mix some yellow ochre and alizarin crimson and brush the faces wet on dry. Soften the edges next to the areas to be left white with a small soft brush and a little water.

2 When dry, use paper towels to blot some colour out from the lighter highlights of the faces, including the lights on the eyebrow ridges, which show above the eyebrows.

painting sequence

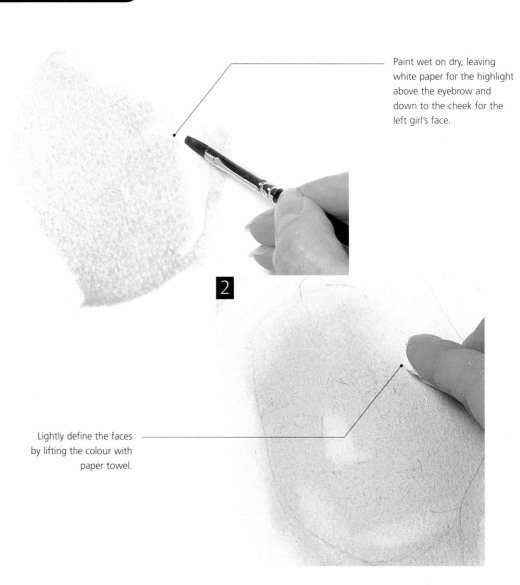

1

Paint wet on dry, leaving white paper for the highlight above the eyebrow and down to the cheek for the left girl's face.

2

Lightly define the faces by lifting the colour with paper towel.

3 Using a #22 brush, add some base colour to the hair with quinacridone gold. With the same brush, apply a variegated wash of cobalt blue and Hooker's green to the background.

4 Using a tissue, mop off any green that has run into the hair.

5 Using the #22 brush, paint some cobalt blue thinly into the hair of the girl on the right, then use the same colour for the girl on the left. Mix ultramarine blue and light red to make a grey. Add a wash of clean water below the chin, and paint the mix with a #2 brush. Allow the colour to flow downwards, fading away from the chin and thus creating a lost-and-found edge.

6 Using a smaller brush, add some alizarin crimson to the faces. Using a #6 brush, use cobalt blue for the eyes of the girl on the left.

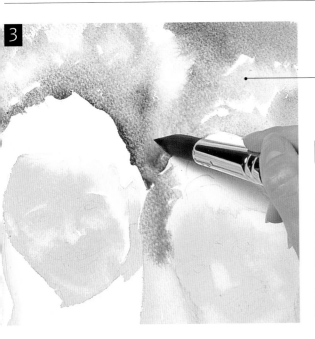

The addition of the green colour behind the faces will suggest some leaves and flowers.

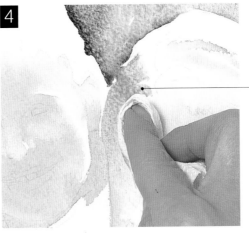

Here, some green has invaded the hair and is being mopped off.

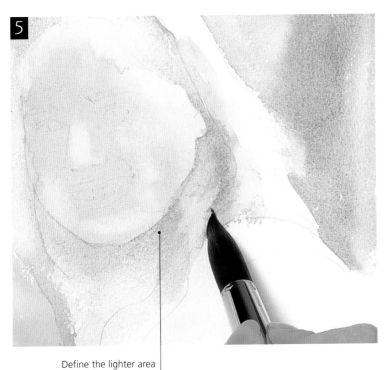

Define the lighter area of the chin with the dark colour below.

Paint the alizarin crimson wet in wet into the left girl's face.

7 Using a #2 brush, use burnt umber with a touch of cobalt blue for the eyes of the boy.

8 Paint the interior corners of the right girl's mouth, on the edges of the dental arch.

9 Glaze the boy's face using Hooker's green.

10 Brush cadmium orange onto the left side of the left girl's face. Leave to dry and then lift colour from the cheeks with damp paper towel.

painting sequence

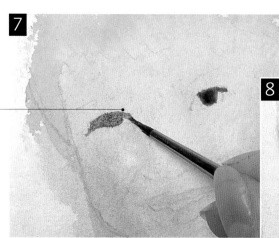

Using the point of a fine #2 brush, apply burnt umber with cobalt blue for the brown of the eyes.

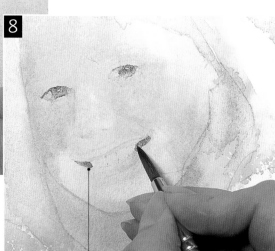

Using burnt umber and cobalt blue with a slightly blue bias, paint the interior corners of the right girl's mouth.

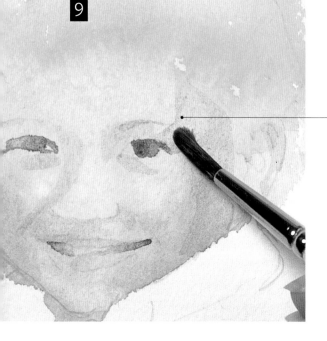

Paint Hooker's green onto the boy's face in a thin wash, wet on dry.

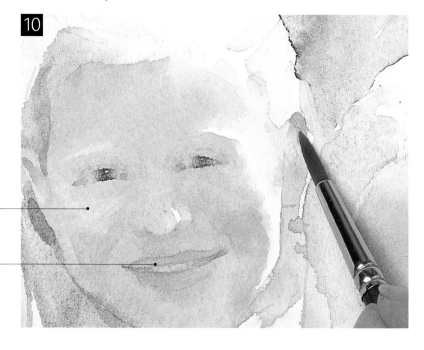

The side of the left girl's face is built up with cadmium orange, further enhancing the white highlight.

Nostrils, ears and lips are modelled with a cadmium orange and alizarin crimson mix.

11 Apply cadmium orange for the undertone on all the heads. Leave to dry, then carefully wet parts of the heads, leaving dry streaks for the highlights. Apply a mix of cobalt blue and burnt umber to this. Begin to define the darks around the top of the boy's head. Leave to dry. Wet the front of the boy's hair and apply the burnt umber and cobalt blue mix. It should be dark along the edge, but allow it to blend into the wet wash. Use the colour to define edges with negative painting.

12 Mix a mauve-grey of light red and ultramarine blue. Use water to fill in the shape of the shirt of the girl on the left, also carefully define the boy's head by painting water around it without going over the edge. Now apply the mauve-grey mix from the left side of the shirt and around the neck, letting it spread inwards.

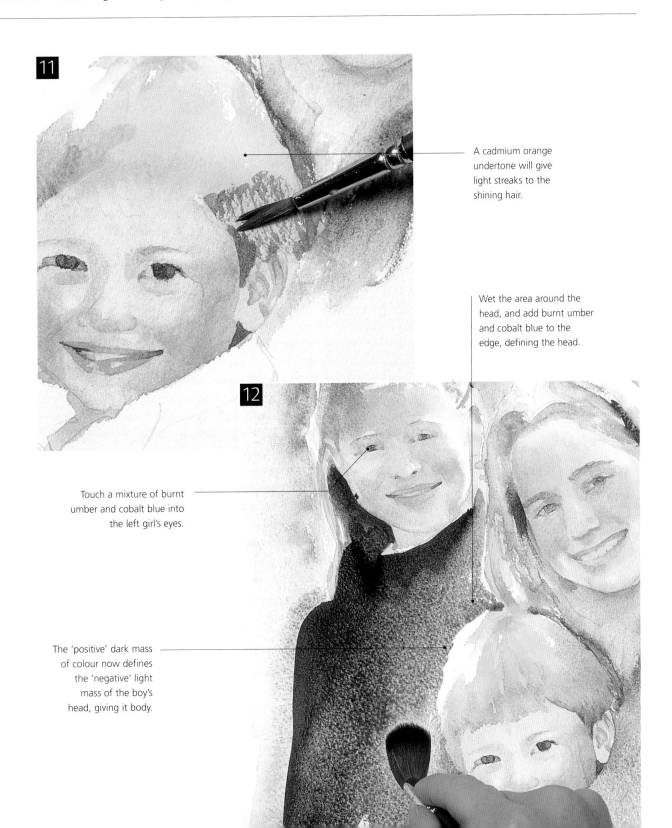

A cadmium orange undertone will give light streaks to the shining hair.

Wet the area around the head, and add burnt umber and cobalt blue to the edge, defining the head.

Touch a mixture of burnt umber and cobalt blue into the left girl's eyes.

The 'positive' dark mass of colour now defines the 'negative' light mass of the boy's head, giving it body.

13 Mix light red and ultramarine blue to make a granulating mauve, and brush this, wet in wet, around the right girl's chin (as demonstrated in Step 12). Paint darks into her hair with this mix. Make a watery mix of Hooker's green and yellow ochre and, using a 5mm (³⁄₁₆") flat brush, paint a thin glaze of this onto all three faces, wet on dry.

14 Mix some phthalo blue and burnt umber and paint the shadows under the eyebrows using a #2 brush.

15 Paint the eyebrows with a mix of light red and ultramarine blue. Apply it along the tops of the left girl's eye sockets with a #2 brush.

painting sequence

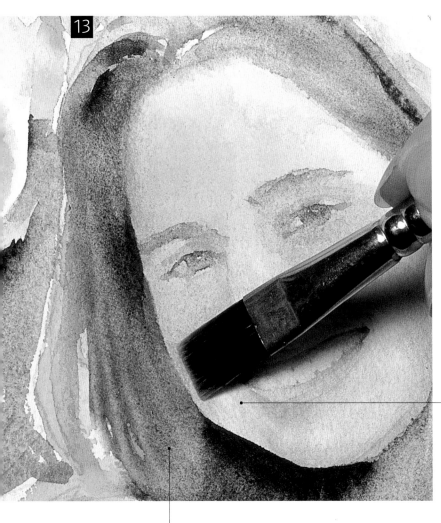

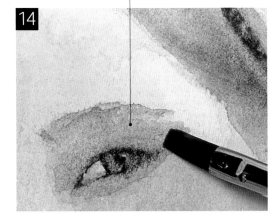

Phthalo blue and burnt umber are 'glazed' over the previous shadow under the eyebrows.

It is easy to correct mistakes as you go along. Here, some hair colour was spilt onto the cheek and was lifted off with a damp flat brush.

Leave the hair to dry naturally to preserve the granulation.

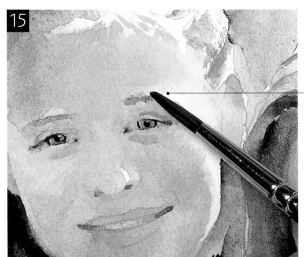

Leave some light above the eyebrows to accentuate their shape.

16 Paint the eyebrows of the girl on the right with burnt umber. Using a mixture of alizarin crimson and a little yellow ochre, paint the girls' lips.

17 Brush the boy's eye sockets using a mix of alizarin crimson and burnt umber. Use this colour to add structure to his face. Then paint the boy's shirt with cobalt blue mixed with a little burnt umber.

18 Use a #2 brush and burnt umber to paint a fine line on the boy's eyelid. Use the same brush and colour to paint the fine detail around the boy's eye.

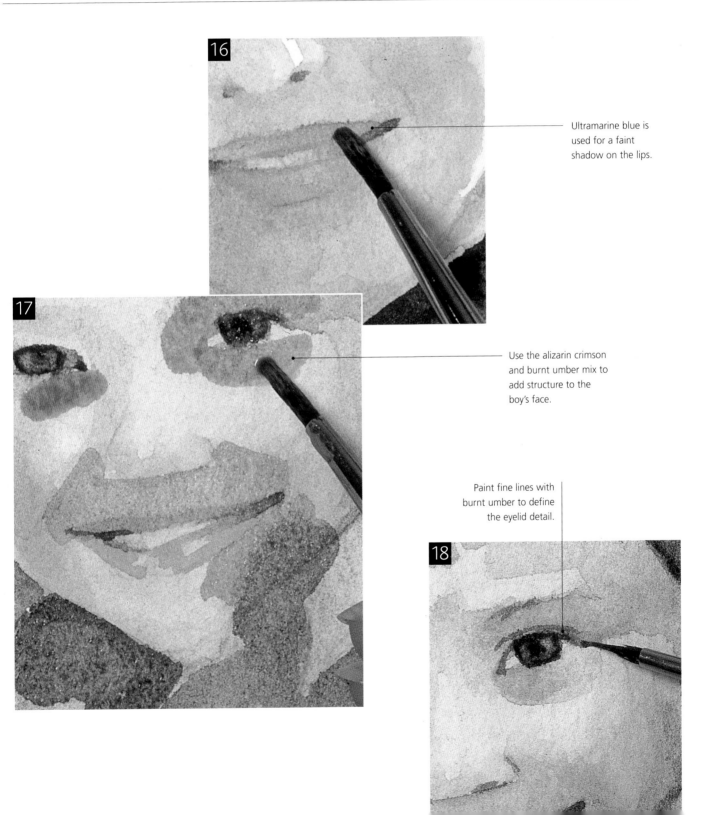

Ultramarine blue is used for a faint shadow on the lips.

Use the alizarin crimson and burnt umber mix to add structure to the boy's face.

Paint fine lines with burnt umber to define the eyelid detail.

19 Use a #22 brush to apply a wash of ultramarine blue and burnt sienna to the shirt of the girl on the right.

20 Brush a mix of ultramarine blue and burnt umber, wet on dry, onto the girl's hair, with a #6 brush.

21 Wet the background with clean water and then build up a wash of Hooker's green, wet in wet, adding viridian. Add ultramarine blue, alizarin crimson and burnt umber into this for the shadow. Leave to dry so that it granulates.

painting sequence

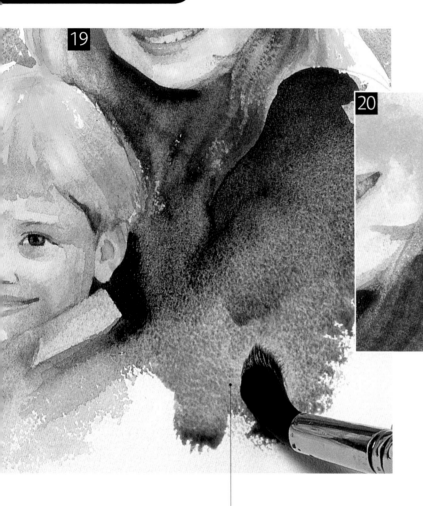

Use wet-on-dry brushstrokes of ultramarine blue and burnt umber for the girl's hair.

Finishing with loose wet-on-dry brushstrokes gives the painting spontaneity and immediacy.

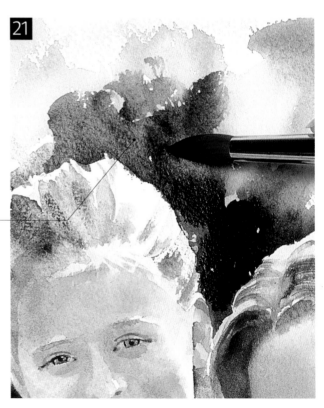

Hooker's green and viridian are brushed loosely around the head into a wash of clean water to define light highlights. Add the dark colour into this wet in wet.

The Finished Painting Children can be notoriously difficult to paint because their faces are so smooth and unlined, but here, the artist has captured not only the beauty of the children's faces, but also a real sense of mood and atmosphere. Although the artist does not fastidiously record every tiny detail, the subjects are bursting with life and energy, and the representation is in many ways as lifelike as a photograph.

Family portrait

by Glynnis Barnes Mellish

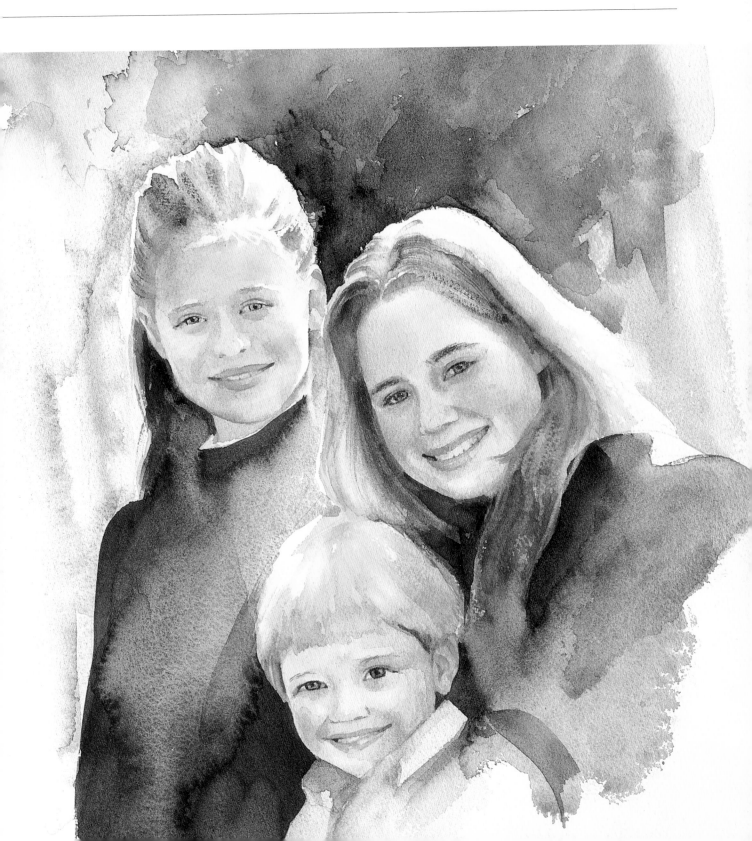

7·Tuscan vineyard

This painting is a fine example of how colour and texture can be built up to create a real sense of space and perspective. The techniques employed are simple, but a variety of different brushstrokes creates a wealth of tones and shadings, perfect for recreating the Italian countryside.

1 Using a B pencil, draw a villa on top of a small rounded hill, following the painting on page 105, on a piece of tracing paper. Then place the tracing paper over the watercolour paper, right side up, and draw the image over again firmly with the same pencil. Mix some cerulean blue with water – prepare enough for this and the next step. Wet the sky area with clean water. Then, using a #8 brush, carefully model the water around the villa to save whites. Use a #12 brush to paint cerulean blue onto the sky in a wet-in-wet wash. Begin at the top right corner and fade the wash down working towards the left, adding water as you go.

painting sequence

1

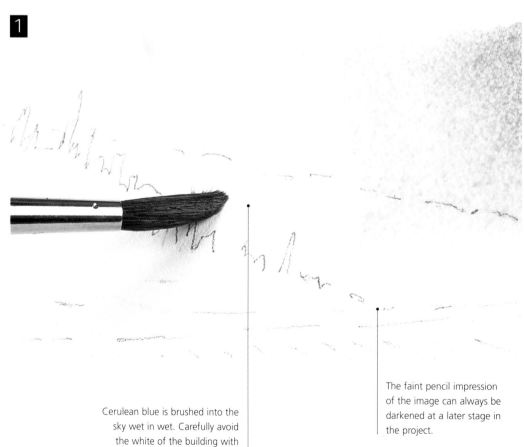

Cerulean blue is brushed into the sky wet in wet. Carefully avoid the white of the building with both the clean water wash and the wet-in-wet application of colour.

The faint pencil impression of the image can always be darkened at a later stage in the project.

2 Mix plenty of new gamboge with water ready for the next step. Wet the lower part of the vineyard, and add new gamboge using a #12 brush. Brush in a streak of new gamboge in the mid-distance vineyard below the hill.

3 Using a #12 brush and a cool cadmium lemon, paint wet on dry onto the field below the hillside, in a strip above the new gamboge. Then drybrush cadmium lemon onto the hillside olive grove.

4 Prepare ultramarine blue and cerulean blue separately with water. Mix quinacridone red and cadmium lemon with water ready for the next step. Wet the distant ridge area, leaving the hill with the villa dry. Loosely define the ridge along its top edge. Avoid wetting all other areas and leave the detail modelling until you go back with colour. Add a wash of cerulean blue and ultramarine blue to the wet area.

5 Define the hillside edges and the villa with the blue wash, drawing the water and colour out of the edge of the wet wash and onto the saved dry areas.

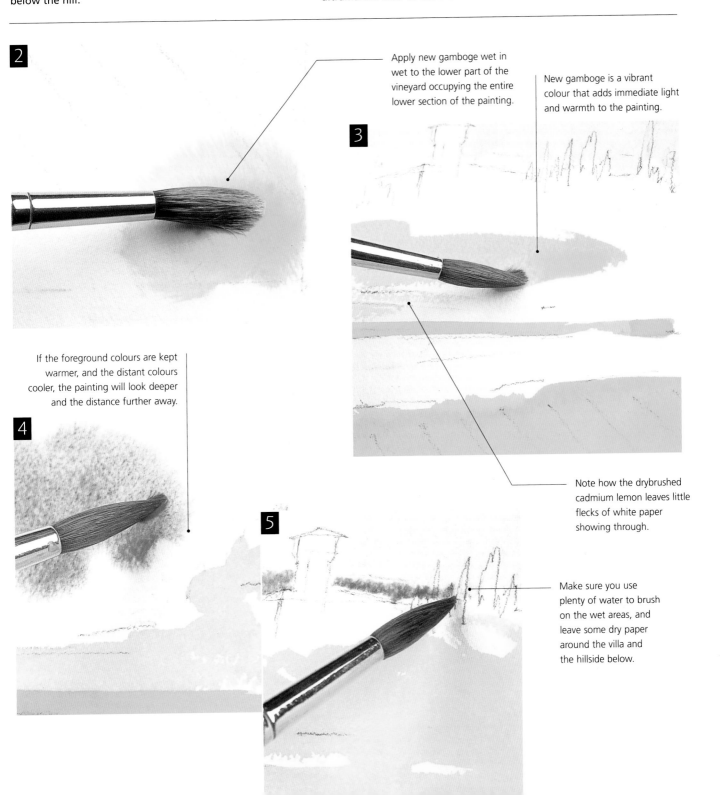

2

Apply new gamboge wet in wet to the lower part of the vineyard occupying the entire lower section of the painting.

New gamboge is a vibrant colour that adds immediate light and warmth to the painting.

3

If the foreground colours are kept warmer, and the distant colours cooler, the painting will look deeper and the distance further away.

4

Note how the drybrushed cadmium lemon leaves little flecks of white paper showing through.

5

Make sure you use plenty of water to brush on the wet areas, and leave some dry paper around the villa and the hillside below.

6 While the wash is still wet, use a #4 brush to add a mix of ultramarine blue and a touch of quinacridone red into the lower part. Then add the colour mix to the wash on the ridge on the far side of the villa. Before it dries, use a #4 brush to drop a little cadmium lemon, wet in wet, into the ridge wash on both sides of the villa.

7 Now drop some quinacridone red and ultramarine blue into the wet wash on either side of the villa, letting the colours blend. Dry it with a hairdryer.

8 Mix light red and quinacridone red and paint the villa roofs. Brush a loose wash of viridian over the hillside. Next, paint the nearer grove that stretches along the foot of the hillside, using phthalo green diluted in a generous mix of water.

9 Finish the band of phthalo green, then, while it is still wet, drop in cadmium lemon and spread it with a brush.

painting sequence

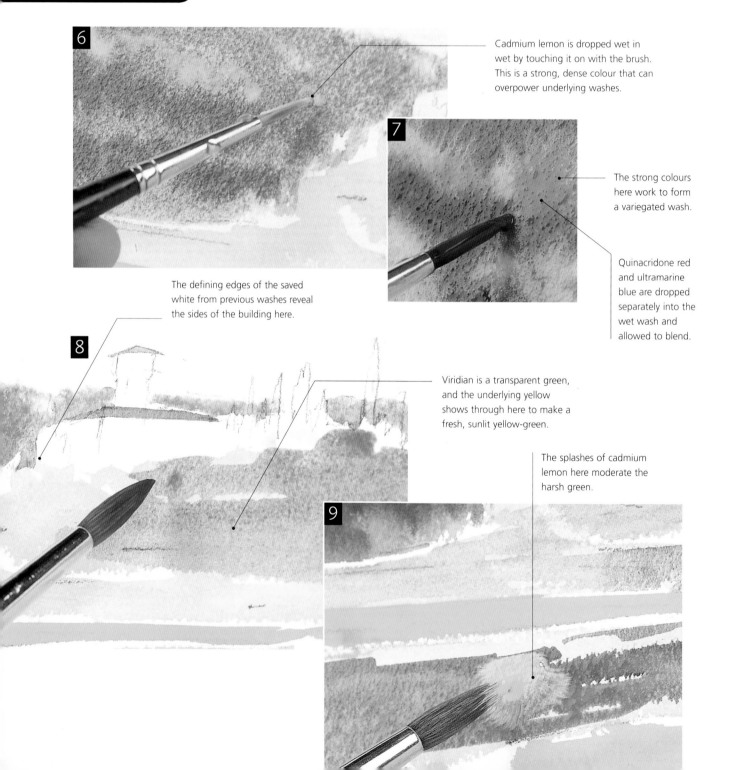

Cadmium lemon is dropped wet in wet by touching it on with the brush. This is a strong, dense colour that can overpower underlying washes.

The strong colours here work to form a variegated wash.

Quinacridone red and ultramarine blue are dropped separately into the wet wash and allowed to blend.

The defining edges of the saved white from previous washes reveal the sides of the building here.

Viridian is a transparent green, and the underlying yellow shows through here to make a fresh, sunlit yellow-green.

The splashes of cadmium lemon here moderate the harsh green.

10 Mix a blue-grey colour of ultramarine blue and burnt sienna. Brush this into the shadow areas of the building. Next, model form with the shadow colour, and paint the window apertures with vertical strokes of colour. Leave the building colours to dry.

11 Mix some burnt sienna and cerulean blue. Using a #4 brush with clean water, gently brush or feather this colour onto the hillside with up-and-down strokes. Leave gaps of dry paper in between the strokes and move to the next step before this water dries. Using burnt sienna and cerulean blue and the point of a #4 brush, paint lines of colour through the wet area on the hillside. Finish the hillside using this technique.

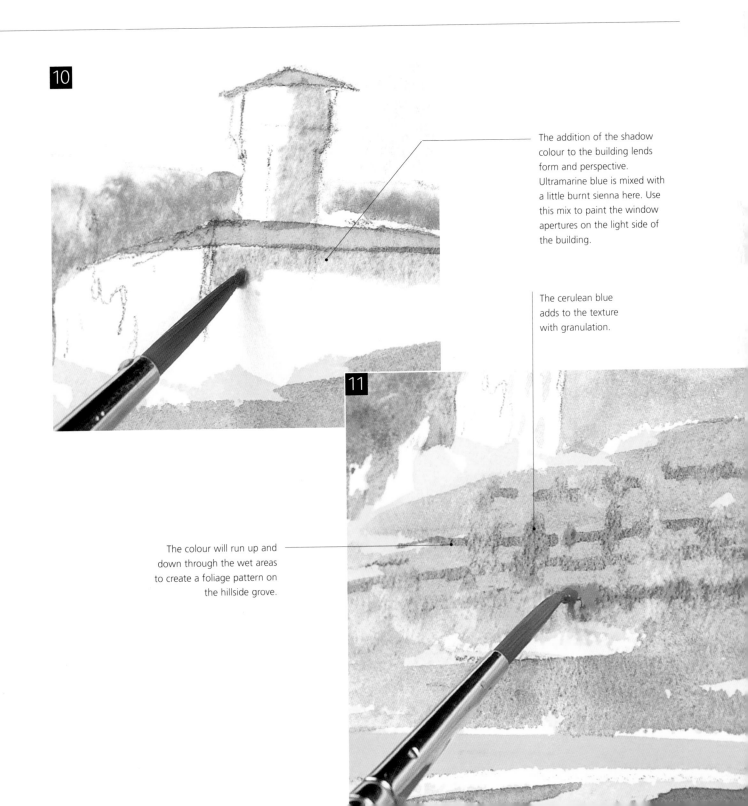

The addition of the shadow colour to the building lends form and perspective. Ultramarine blue is mixed with a little burnt sienna here. Use this mix to paint the window apertures on the light side of the building.

The cerulean blue adds to the texture with granulation.

The colour will run up and down through the wet areas to create a foliage pattern on the hillside grove.

12 Mix quinacridone red and phthalo green to make a blackish green. Add a little ultramarine blue for the distance, and add a little water to make it paler. Brush the trees to the left of the villa, wet on dry, with a #4 brush. Use vertical strokes of this colour to make the needle shapes of the cypress trees, and finish all the trees on the hillside. Make a black from quinacridone red and phthalo green and add a little ultramarine blue to bias it towards blue. Dilute with a little water and paint in the darker windows and dark accents in the shadows.

13 Drybrush a dark green mix of phthalo green and quinacridone red for the darker shadow in the hillside grove. Then re-wet the shadow side of the building and touch in a little of this colour to the base.

painting sequence

12

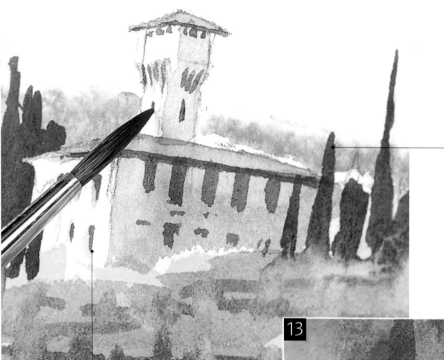

This blackish green is excellent for evergreen trees.

Brush a little water with a drybrush technique, and then brush a cerulean blue and burnt sienna mix in up-and-down dry brushstrokes for the edge of a distant vineyard.

Notice how the small marks of dark window aperture colour do not fully cover the underlying marks of the lighter colour from Step 10.

13

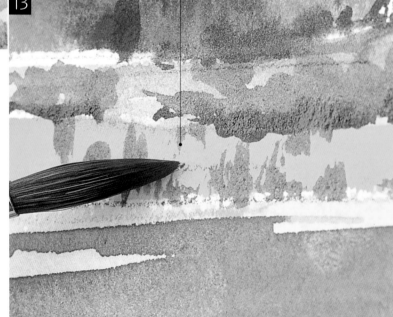

14 Brush a little water onto the yellow streak at the foot of the hill, and then brush cerulean blue mixed with a little burnt sienna in vertical streaks. Use a #4 brush to apply a mix of phthalo green and quinacridone red to create dark streaks in the vineyard.

15 Wet the hillside and run streaks of cerulean blue along it, wet in wet, as shown below. The colour will spread upwards into the wet, but will form a sharp edge where it is dry along the base, making a lost-and-found edge.

16 Mix phthalo green and cadmium lemon to make a bright green. Using the point of a #4 brush, paint the gaps between the vines.

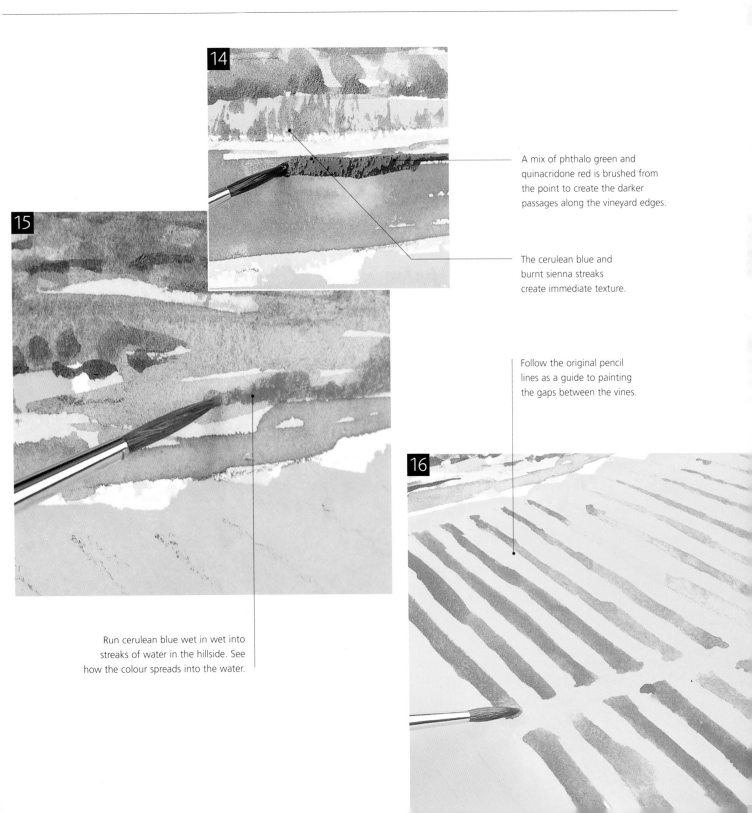

A mix of phthalo green and quinacridone red is brushed from the point to create the darker passages along the vineyard edges.

The cerulean blue and burnt sienna streaks create immediate texture.

Follow the original pencil lines as a guide to painting the gaps between the vines.

Run cerulean blue wet in wet into streaks of water in the hillside. See how the colour spreads into the water.

17 Brush the end of the field with the dark green mix of phthalo green and quinacridone red. Paint a series of almost triangular shapes to define the ends of the vines. Add a little cadmium lemon to the top of each triangle while it's still wet. Add some burnt sienna to the green vineyard mix to create a brownish green. Drybrush this onto the vines, then use the dark green mix of phthalo green and quinacridone red to drybrush a darker texture onto the grassy gaps between the vines.

18 Use the brownish green to drybrush vertical texture onto the sides of the vines where they become visible. Use a mix of indigo and phthalo green to brush the foreground cypress trees in front of the fields.

painting sequence

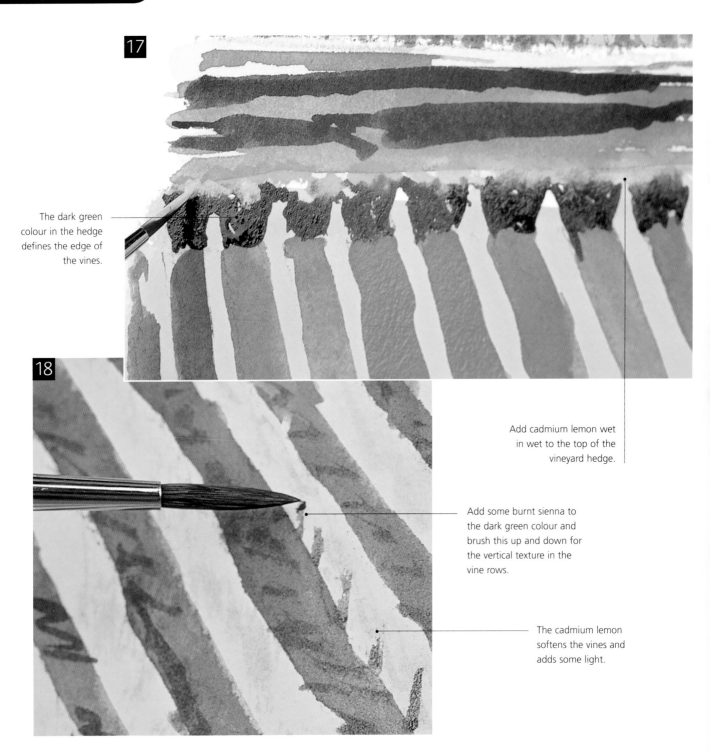

The dark green colour in the hedge defines the edge of the vines.

Add cadmium lemon wet in wet to the top of the vineyard hedge.

Add some burnt sienna to the dark green colour and brush this up and down for the vertical texture in the vine rows.

The cadmium lemon softens the vines and adds some light.

The Finished Painting The eye is drawn along the vertical lines of the vines to where the villa rests on top of the hill. The gentle undulations of the land, the warm, bright colours and the sense of open space, fading into a gentle blue in the distance, are tremendously evocative of Italy at harvest time. One can almost see the vines heavy laden with fruit, and hear the chimes from the bell tower ringing over the surrounding countryside.

Tuscan vineyard

by Joe Francis Dowden

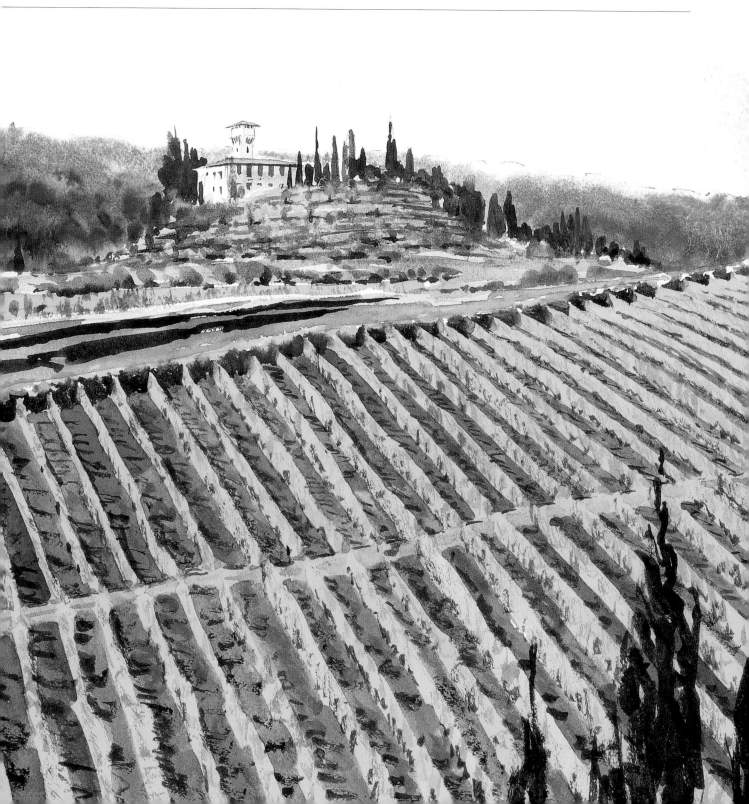

8·Sailing in Zanzibar

Coastal themes provide ideal subjects for the beginner in watercolour. Clean bright colours and sharp contrasts of texture and tone lend themselves to a really fresh composition. Vibrant shades can be achieved by working with and mixing a very basic palette, and there's lots of room for experimentation here.

materials

Colours: cadmium lemon, quinacridone red, cobalt blue, ultramarine blue, cobalt turquoise light, phthalo green, Chinese white, burnt sienna, indigo, yellow ochre

Watercolour paper: 140 lb cold pressed

Brushes: #8, #2

3B pencil

Palette consisting of separate pans

Two containers of clean water, one for mixing and diluting your paint and one for rinsing your two brushes.

1 Staple a wet sheet of watercolour paper to a board. Leave it to dry and stretch. Protect the edges with masking tape. With a 3B pencil, sketch the main outlines of the painting on page 111. Mix a large quantity of strong ultramarine blue. Wet the sky with a #8 brush and clean water, avoiding the cloud shapes and the boat sail. Paint water under, around and above the clouds, allowing extra space around them for when you paint the sky. Use a #8 brush to add ultramarine blue, brushing it onto the wet areas of the sky. Model the edges of the clouds by painting around them loosely, but still with care.

painting sequence

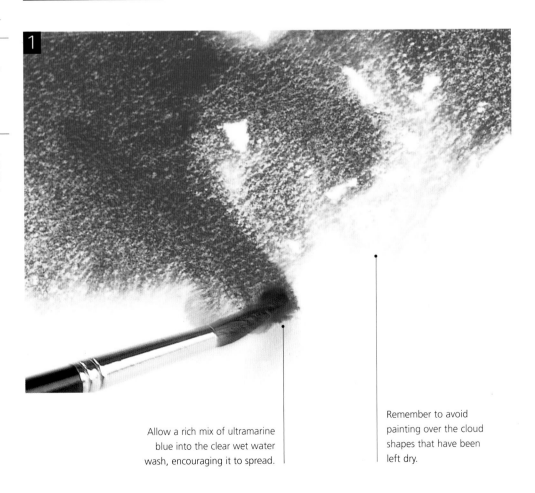

Allow a rich mix of ultramarine blue into the clear wet water wash, encouraging it to spread.

Remember to avoid painting over the cloud shapes that have been left dry.

2 Add a little water to the area below the base of the clouds, down to the horizon line. Remember to avoid the boat sail. Paint beneath the clouds, wet in wet, with diluted ultramarine blue. Allow this to blend into the underside of the clouds with a soft edge. Leave to dry. Mix a generous quantity of cobalt turquoise light. Similar effects can be obtained by mixing phthalo blue, phthalo green and Chinese white. Wet the sea area down to the edge of the beach with clean water on a #8 brush, saving the whites of the boat and sail. Using a #8 brush, add the cobalt turquoise light, wet in wet, allowing it to spread through the water. Be careful not to go over the whites for the boat. Continue to work wet in wet, painting around the boat.

3 Add a fine line of indigo to the horizon, beneath the ultramarine blue, avoiding the boat sail. Re-wet with water and then run a line of indigo along the distance below the horizon.

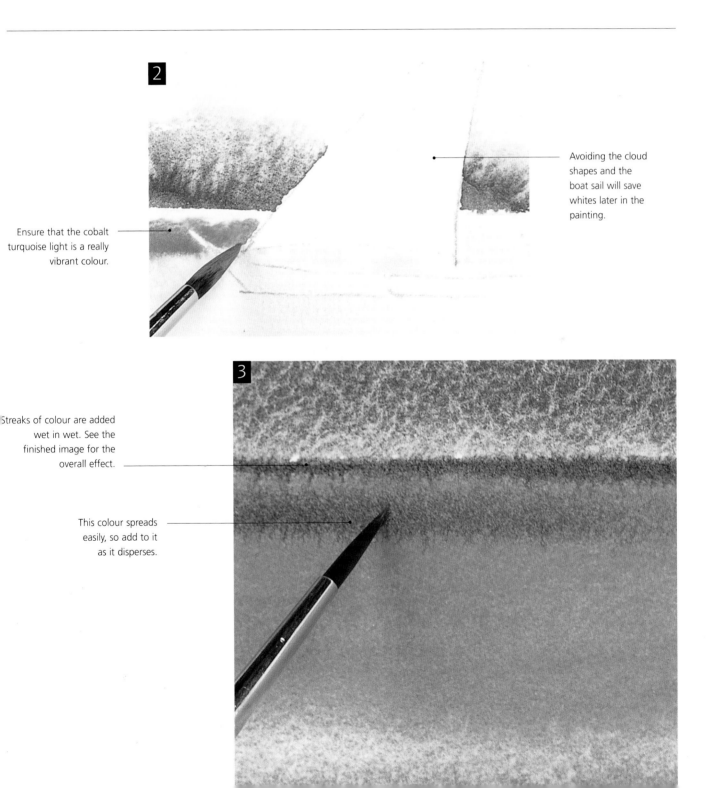

2

Ensure that the cobalt turquoise light is a really vibrant colour.

Avoiding the cloud shapes and the boat sail will save whites later in the painting.

3

Streaks of colour are added wet in wet. See the finished image for the overall effect.

This colour spreads easily, so add to it as it disperses.

4 Prepare to paint the clouds by making pools of cobalt blue, yellow ochre and quinacridone red. Mix a blue-grey, with a slight violet bias, with cobalt blue, quinacridone red and yellow ochre. Wet the clouds with clean water and apply the blue-grey mixture with a #8 brush. Start with one patch and finish before you move on to another. Have some clean, dry tissue paper at the ready.

5 Add more colour to the middle of the clouds, then dab some tissue below the colour.

6 Return to the base of the clouds and darken with the grey mixture. Dry with a hairdryer. Re-wet the sea and use a #8 brush to paint a stripe of cerulean blue across it. With a #2 brush, add a tiny accent of burnt sienna in the foreground.

painting sequence

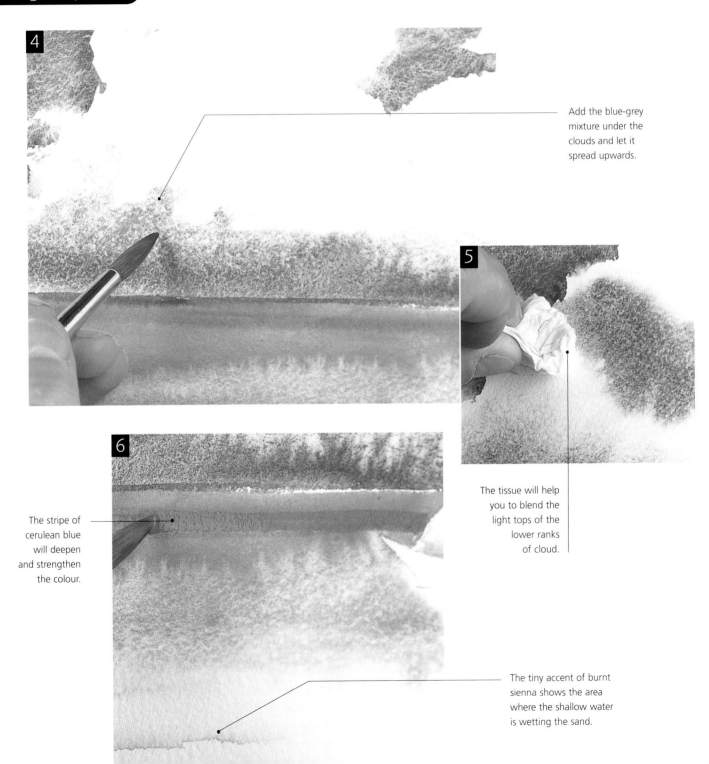

Add the blue-grey mixture under the clouds and let it spread upwards.

The tissue will help you to blend the light tops of the lower ranks of cloud.

The stripe of cerulean blue will deepen and strengthen the colour.

The tiny accent of burnt sienna shows the area where the shallow water is wetting the sand.

7 Mix some cadmium lemon with a little burnt sienna. Make sure the sky is absolutely dry, then use a #8 brush to add some colour, wet on dry, to the palm tree fronds. Next, paint around the tree trunks lower down. When this is dry, add some marks of phthalo green over the fronds.

8 Make a very dark green with indigo and phthalo green, adding a little burnt sienna. With a #8 brush and clean water, lightly brush across the surface of the paper and feather over parts of the darker fronds. Then brush the darker palm fronds with the point of the brush, through the feathered area.

9 Paint the ragged tree line along the horizon with the dark mixture of indigo, phthalo green and burnt sienna.

10 Mix phthalo green, cadmium lemon and burnt sienna and use a #4 brush to touch in green around the foot of the trees, leaving the trunks white. With a #4 brush, wet the trunks. While still wet, touch in one side with burnt sienna and add a thin line of indigo.

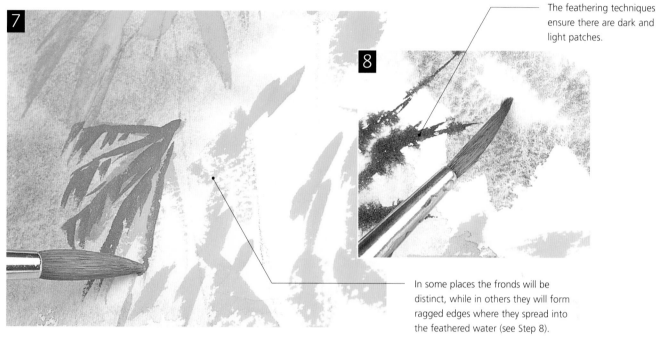

The feathering techniques ensure there are dark and light patches.

In some places the fronds will be distinct, while in others they will form ragged edges where they spread into the feathered water (see Step 8).

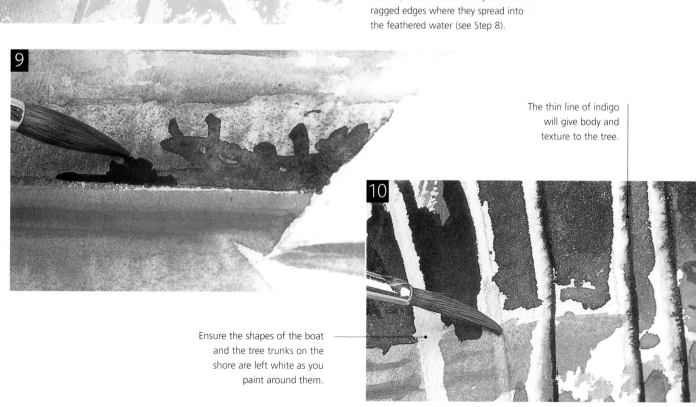

The thin line of indigo will give body and texture to the tree.

Ensure the shapes of the boat and the tree trunks on the shore are left white as you paint around them.

11 Brush linear marks with a mix of cobalt blue and burnt sienna onto the fabric of the boat sail. Leave to dry. Add burnt sienna and use a #4 brush to paint the patches on the sail. Leave to dry. Next, add a darker mixture of burnt sienna and cobalt blue for shadows and texture.

12 Use a fine #2 brush to paint the mast and spar with indigo. Touch in the boat and figures with a warm brown mixture of burnt sienna and cobalt blue. Leave to dry. Paint a mix of cobalt blue and burnt sienna onto the boat. Wet the water below the boat and run in a mix of indigo and cobalt blue for the dark reflection. Brush a few linear ripples, wet on dry, on either side of the light sail reflection in the water.

13 Brush burnt sienna in long lines with a #8 brush across the beach. Add more of these with long snaking lines in the foreground, and add some indigo to them in places when they are dry. Touch the figures in with a little indigo.

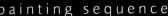

painting sequence

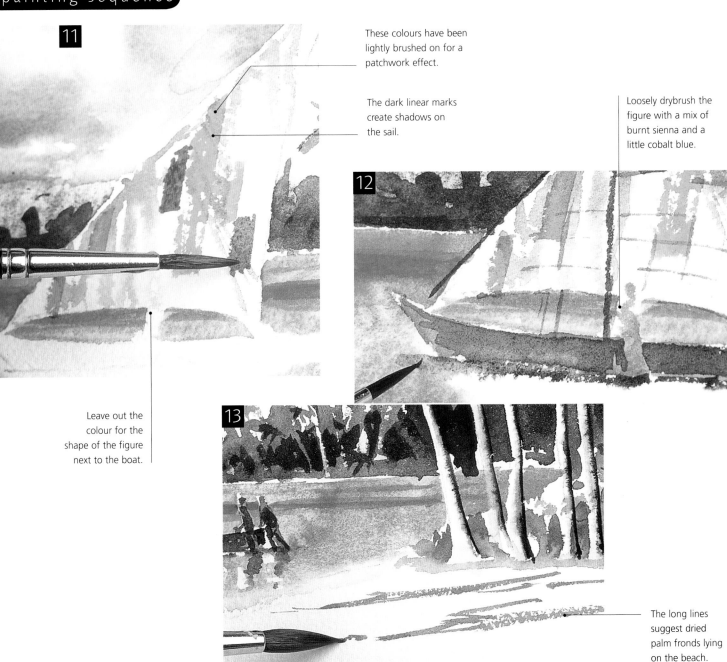

11

These colours have been lightly brushed on for a patchwork effect.

The dark linear marks create shadows on the sail.

Loosely drybrush the figure with a mix of burnt sienna and a little cobalt blue.

12

Leave out the colour for the shape of the figure next to the boat.

13

The long lines suggest dried palm fronds lying on the beach.

The Finished Painting 'There is a tremendous sense of space to the finished painting. The relatively small amount of detail in the foreground is highlighted by the huge vista of open sea and sky. Note how the centre of the painting – the boat – is slightly offset to the right, balanced by the eye being drawn to the left out to the open sea.

Sailing in Zanzibar

by Joe Francis Dowden

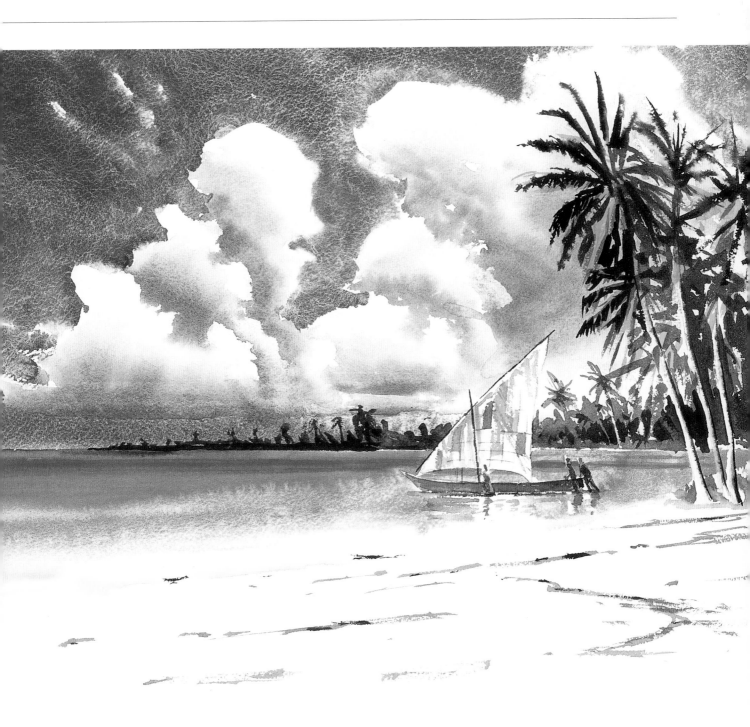

9·Copse of trees

materials

Colours: Naples yellow, cadmium lemon, burnt sienna, cerulean blue, quinacridone red, ultramarine blue

Watercolour paper:
140 lb cold pressed

Brushes: #8, #6, #12, #4

Toothbrush

Masking fluid

Colour shaper

Palette consisting of separate pans

Two containers of clean water, one for mixing and diluting your paint and one for rinsing your four brushes.

The beauty of this composition lies in the interplay of colours of the sparkling sunshine and the deep vivid shades of the autumn leaves. Spattering and masking are shown off to great effect here, both employed in very simple ways to achieve stunning results.

1 To show the light where the sun catches the side of the trees in the painting on page 117, use masking fluid on a colour shaper to mask each tree all the way down its left edge. With the same brush, use masking fluid to create rough jagged shapes in the woodland canopy. These will be patches of light sky. Dip a toothbrush in masking fluid, and spatter into the woodland canopy. Allow to dry.

2 With a #6 brush, paint the woodland on the far bank of the lake with a mix of Naples yellow, burnt sienna and cadmium lemon. Next, spatter water into the sky and woodland using a #8 brush. Spatter the yellow woodland mixture into the wet area, then brush a few lines of this colour through the woodland canopy and leave it to dry.

painting sequence

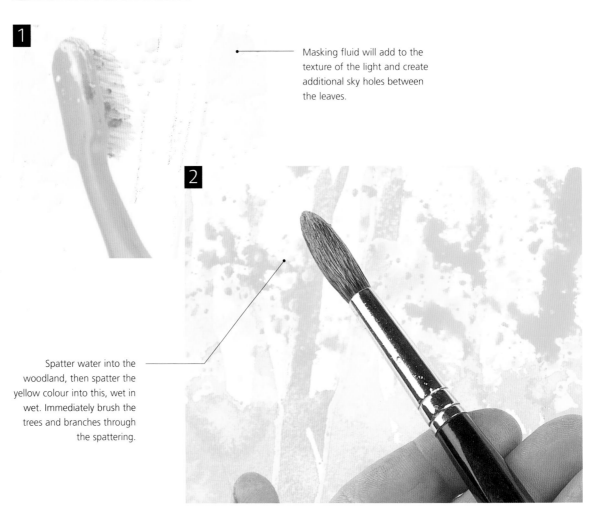

Masking fluid will add to the texture of the light and create additional sky holes between the leaves.

Spatter water into the woodland, then spatter the yellow colour into this, wet in wet. Immediately brush the trees and branches through the spattering.

3 Wet the blue sky reflection area on the lake, keeping the rest of the lake and the near shore dry. Add cerulean blue, wet in wet, to create the reflection of the sky in the water. Prepare some cadmium lemon, burnt sienna, quinacridone red and ultramarine blue separately. Using a #6 brush, apply washes of cadmium lemon and burnt sienna while the sky reflection on the lake is wet.

4 Start painting the wash for the reflection of the woodland. Add some quinacridone red to this wash in places. Leave a few white lights for autumn leaves. Make darker areas by adding ultramarine blue to burnt sienna, and run some of this colour into the wet tree reflection, for the dark reflections in the lake.

5 Spatter water into the distant woodland, just above the edge of the lake. Spatter colour into the water and, using the brush conventionally, tease out a few leaf shapes. Leave to dry.

6 Spatter water into the foreground woodland and then spatter a strong mixture of burnt sienna and cadmium lemon. The pattern will simulate leaves with whites in between. The earlier masking will also save whites in another pattern when removed.

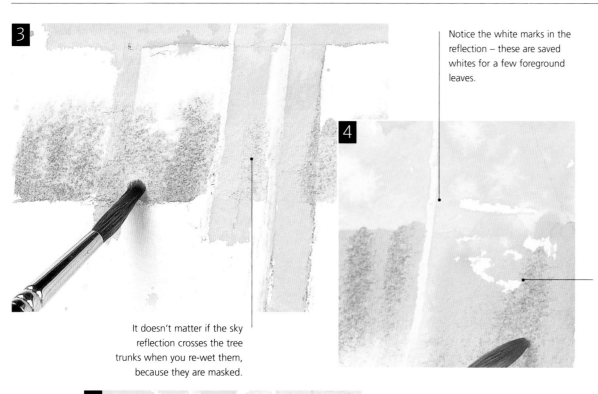

Notice the white marks in the reflection – these are saved whites for a few foreground leaves.

It doesn't matter if the sky reflection crosses the tree trunks when you re-wet them, because they are masked.

It may be necessary to go back and add more colour to achieve the intensity of tone.

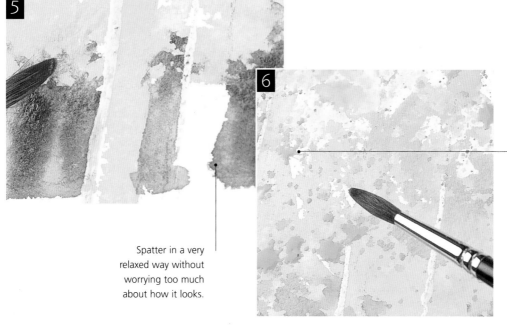

Spatter in a very relaxed way without worrying too much about how it looks.

A labyrinth of autumn leaves starts to appear from the spattering and masking.

7 For the distant wooded foliage on the other side of the lake, wet the woodland and run in a few strokes of Naples yellow, adding quinacridone red and burnt sienna. While it's still wet, add the same dark colour to the lower part of the woodland for the denser shade under the trees. Stop at the waterline to produce further definition of the water's edge. Use ultramarine blue, which adds darkness to the colour. Leave to dry.

8 Use a #8 or #12 brush to paint a ragged wash of cadmium lemon and burnt sienna into the foreground. Work back and forth loosely, creating streaks of colour with whites showing in between. Make the marks a little bigger and broader in the foreground. Leave to dry.

9 With a #8 brush, spatter water into the woodland canopy, and with a mix of ultramarine blue and quinacridone red, drag branch shapes across the spattered area. The branches splay out where they diffuse into the water, but are in sharp focus on dry paper – a very good woodland branch effect. Continue painting the branches. Spatter over them while they are still wet for more of the same effects. Spatter a violet mix of ultramarine blue and quinacridone red into the leaves, and continue brushing branches across the spattered colour. Spatter some of the violet mixture into the spattered water.

painting sequence

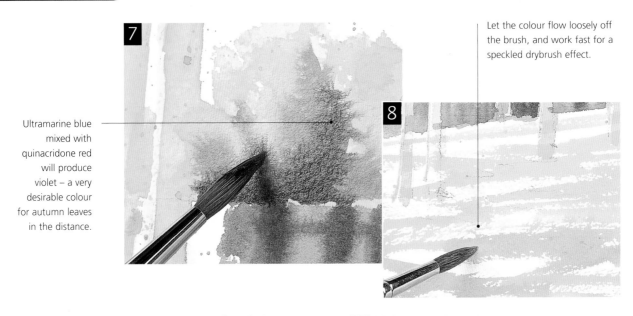

Ultramarine blue mixed with quinacridone red will produce violet – a very desirable colour for autumn leaves in the distance.

Let the colour flow loosely off the brush, and work fast for a speckled drybrush effect.

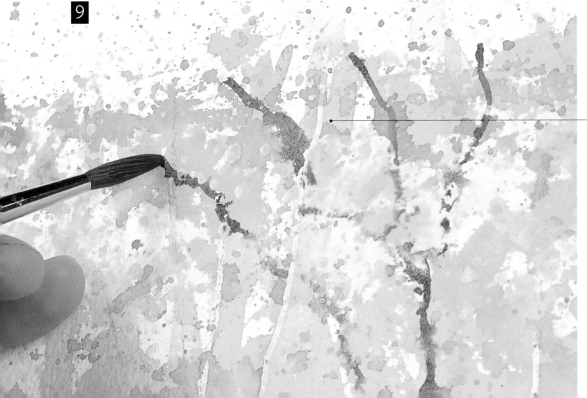

The branches splay out where they diffuse into the water, but are sharply focused on the dry paper – an excellent woodland branch effect.

10 Prepare a mixture of quinacridone red and ultramarine blue violet. Using a #8 brush, wet the tree trunks, leaving a few lights of underlying colour as well as white paper for leaves further up.

11 Paint the colour on the sides opposite the masking fluid, allowing it to spread across again further up the trunks where the leaf canopy begins, saving a few whites. Add water to the ground to produce a lost edge.

12 Continue to work on the forest canopy, spattering water and drawing the violet across with the point of a #8 brush. Spatter a little more colour as you go. The tracery of branches is modelled loosely across.

13 Prepare a strong mix of burnt sienna. Spatter water over the forest floor, and then brush the colour across, with the point of a brush, in streaks.

14 Spatter water into the woodland canopy, then spatter some strong dark colours from the violet mixture for darker accents. Spatter some more water on the forest floor, and drag a darker colour across using the point of a #8 brush. Drag shadows from the foot of the trunks using the violet mix of ultramarine blue and quinacridone red. Leave to dry.

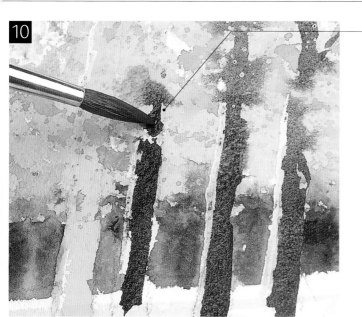

10

Wet the tree trunks by brushing water across and spattering it, then brushing the trunks across, letting them look diffuse in some places, while remaining sharp in others.

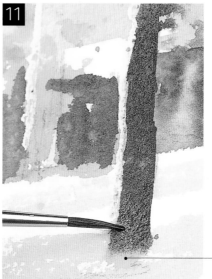

11

The lost edge will make the trees look as though they are growing out of the forest floor.

These darker accents help to enhance the texture.

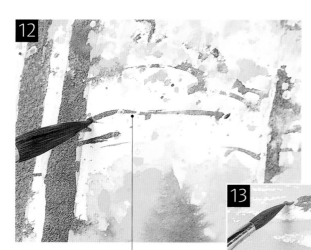

12

Paint diagonally at right angles to the vertical trunks here.

These streaks of colour produce the texture of shadow and autumn leaves.

13

14

15 Peel the masking fluid away, which can be carefully pulled off where it is thick enough; rub off the rest with your fingers to reveal sky holes – more than you'll need. Replace some of the sky holes with colour – a bright cadmium lemon is used here. This will enable you to put in bright autumn colours near the completion of the painting.

16 With a #3 brush, paint trees and branches where they've been broken by the sky holes. Alternatively, loosely clothe them with the autumn leaf colour, so it looks as if leaves are in front of them. When replacing trunks or branches at this late stage, delicately feather a little water across the area you're going to paint, and then brush the branches through the wet area so they diffuse in places and look like part of the forest.

17 With clean water and a #4 brush, gently soften the hard, masked edges of the tree trunks.

painting sequence

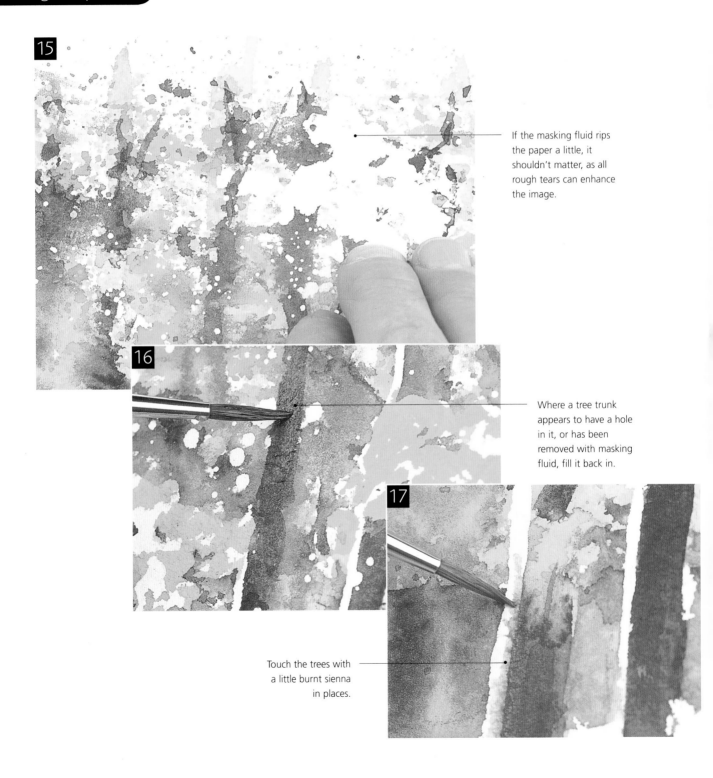

If the masking fluid rips the paper a little, it shouldn't matter, as all rough tears can enhance the image.

Where a tree trunk appears to have a hole in it, or has been removed with masking fluid, fill it back in.

Touch the trees with a little burnt sienna in places.

The Finished Painting Notice how the trees act as a screen between the foreground and background of the picture. Even in the foreground, the effect of detail is achieved by a precise lack of detailed brushwork – this is a composition that lends itself to, and is enhanced by, experimentation and an absence of precision.

Copse of trees

by Joe Francis Dowden

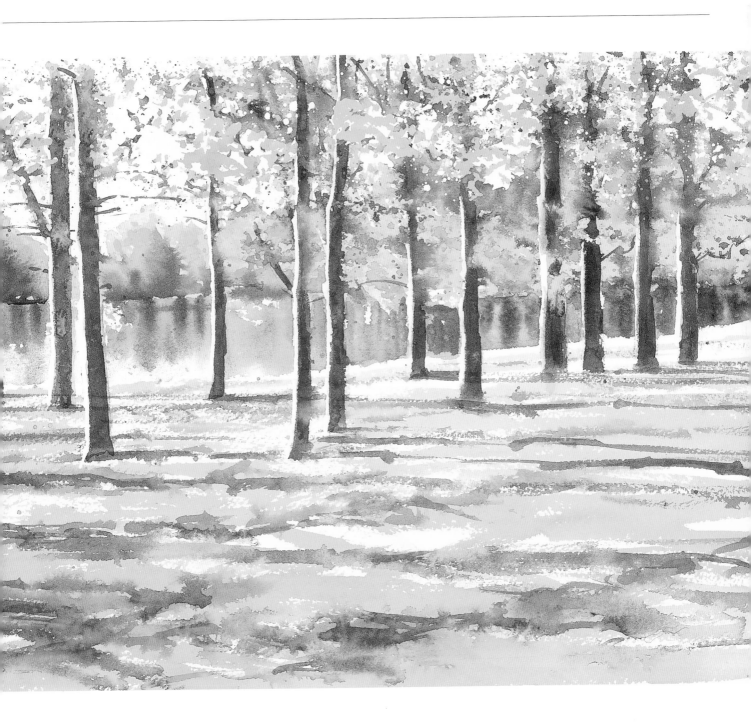

10·Broad sunlit river

materials

Colours: cadmium lemon, quinacridone red, yellow ochre, phthalo blue, burnt sienna, quinacridone magenta, ultramarine blue, cerulean blue, phthalo green, indigo, Payne's grey, cobalt blue, titanium white

Watercolour paper: Whatman 200 lb cold pressed

Brushes: #4, #6, #8, #12, #16, #2, #30 squirrel

2B pencil

Masking fluid, gum arabic

Masking tape

Palette consisting of separate pans

This demonstration displays a wide variety of different techniques, which create a deceptively simple effect. Careful wet-in-wet washes give the river an almost tangible wetness, contrasted with, and highlighted by, delicate and precise brushwork and details.

1 Sketch the lines of the image, then soak the paper and staple it to a board to stretch it and prevent buckling. This is especially important when painting a water scene where the image is going to get very wet. Mask the edges of the image with masking tape. Prepare separate pools of quinacridone red and yellow ochre. Using a #8 brush, wet the sky area from the end of the river upwards to the top of the paper. Avoid wetting the building. Brush quinacridone red carefully into the wet wash, using a #8 brush. Paint around the saved whites of the buildings. Apply the colour low down in the sky area, letting it spread upwards.

2 Add yellow ochre to the sky above the quinacridone red, wet in wet, for a variegated wash. The two colours blend where they meet.

painting sequence

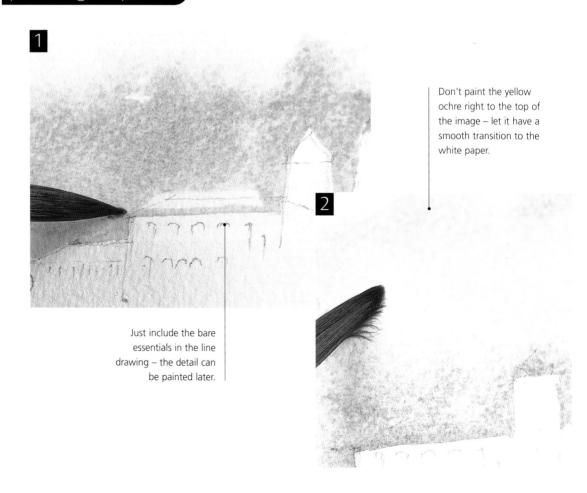

1

Don't paint the yellow ochre right to the top of the image – let it have a smooth transition to the white paper.

2

Just include the bare essentials in the line drawing – the detail can be painted later.

3 Have a #12 brush at the ready. Mix a generous pool of phthalo blue with plenty of water. If the painting has started to dry, don't re-wet it or add paint as this will disturb the colour wash. If this happens, completely dry the paper, and then re-wet it. With a wash of water on the sky, use a #16 brush, wet in wet, to paint a diluted blue from the top right corner. This is the quarter of sky opposite to the sun.

4 Add water to the blue wash as you go, painting over the yellow ochre and quinacridone red to the edge of the saved whites. As you work, save light patches for the trees.

5 While it's still wet, go over the wash with a second, stronger wash of phthalo blue. Look for any lines around the buildings that need defining, and delineate their edges with the point of a brush. This is a graded wash, painted wet in wet. While it's still wet, add water to the bottom of the wash to soften any hard edges.

6 Prepare some cadmium lemon. Using a #16 brush, dip the point in some water and wet the paper in a random pattern, brushing back and forth. Leave some paper dry to be saved along the riverbank. While the paper is still wet, follow the same procedure using cadmium lemon. It mixes with the pattern of water to create a rough textured pattern. Add more clean water and paint in cadmium lemon to build up a sunny under-glaze. Let it go over the blue sky in places so it forms a vibrant green. Dry it with a hairdryer.

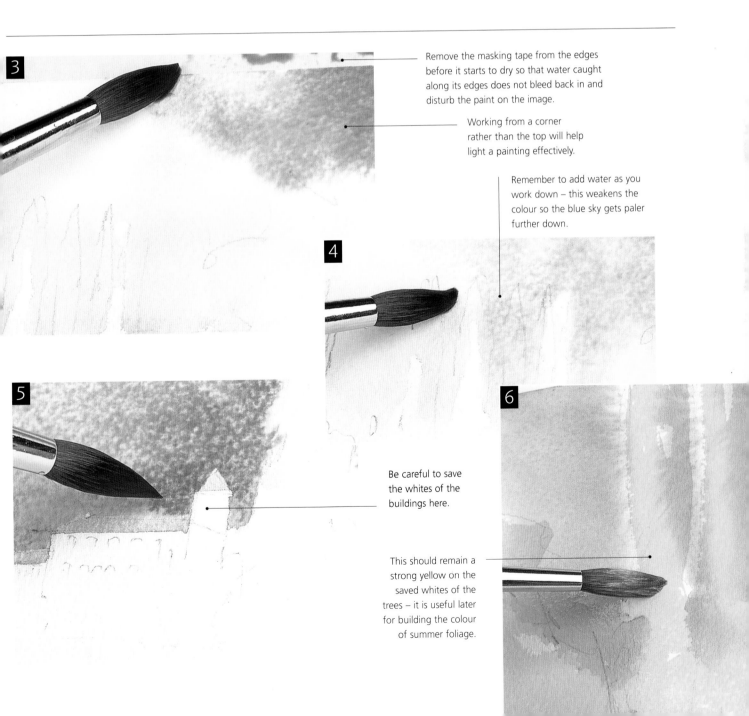

Remove the masking tape from the edges before it starts to dry so that water caught along its edges does not bleed back in and disturb the paint on the image.

Working from a corner rather than the top will help light a painting effectively.

Remember to add water as you work down – this weakens the colour so the blue sky gets paler further down.

Be careful to save the whites of the buildings here.

This should remain a strong yellow on the saved whites of the trees – it is useful later for building the colour of summer foliage.

7 Mask lines in the water. These create bits of sparkling light and strips of broken water, which can be seen from a distance. Prepare a large amount of burnt sienna with plenty of colour and water. Prepare another palette with a large quantity of phthalo blue. Have some clean water at hand, and two clean brushes – one for paint, and one in case you need to re-wet the paper. Wet the river area. Now apply burnt sienna to the river with a medium large brush such as a #16 round sable. Run the burnt sienna upwards about halfway, so it meets white paper along a diffuse edge and stops.

8 While it's still wet, use a #16 brush to apply a strong mix of phthalo blue onto the wet wash from the bottom upwards. Fade the wash upwards by using more water and less paint. Now add quinacridone magenta to the base of the wash, still working wet in wet, and fading the colour as you work upwards. This will turn the colour slightly violet. Brush this in with a #8 or a #12 brush.

9 A clear blue should be emerging from where the phthalo blue sits on the white paper.

painting sequence

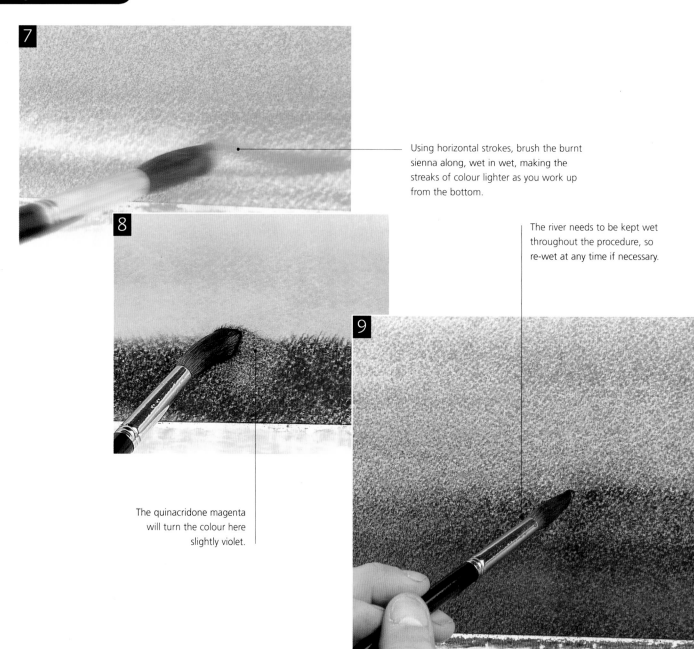

Using horizontal strokes, brush the burnt sienna along, wet in wet, making the streaks of colour lighter as you work up from the bottom.

The river needs to be kept wet throughout the procedure, so re-wet at any time if necessary.

The quinacridone magenta will turn the colour here slightly violet.

10 Mix a green with cadmium lemon, phthalo green and burnt sienna. Have this ready to apply. Using the side of a #12 brush, streak some water onto the riverbank foliage. Let the water pick up on the surface of the paper but leave dimples of dry paper between the streaks. Apply the green from the point of the brush, letting it spread on the surface. Then, using a smaller brush (a #6 or #4) and with the foliage still wet, drop ultramarine blue into the shadow areas. Add water to the distant trees and the riverbank below. Use a mix of ultramarine blue and a little burnt sienna to darken the shadow sides of the poplar trees. Add cerulean blue to add texture. Use a green mix of cadmium lemon and phthalo green to continue building foliage.

11 Define the edge behind the distant building by wetting and adding ultramarine blue along the rooftop as shown. Brush the trees in with a dark green mix of phthalo green, burnt sienna and indigo.

12 Glaze the left bank area with a yellow-based mix of burnt sienna and cadmium lemon, leaving flashes of white paper as well as some of the previous underlying colour. Now you can use up some of the darks from the palette. Strengthen them with indigo or Payne's grey if necessary. Criss-cross clean water onto the trees and use a #6 brush to paint in the dark colour.

13 Add cadmium lemon to the poplar trees. Dab a strong mixture into the wet trees with a #2 brush and let it spread. Dot it about and leave to dry. Touch in the building with a little yellow ochre, wet on dry.

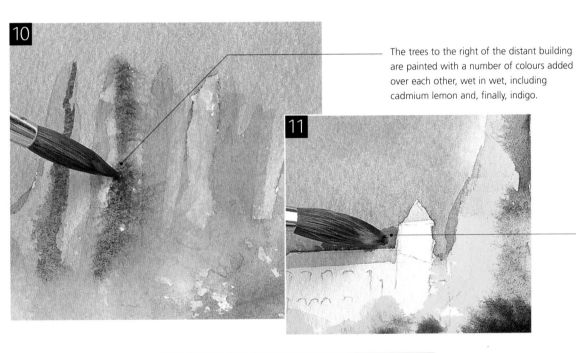

The trees to the right of the distant building are painted with a number of colours added over each other, wet in wet, including cadmium lemon and, finally, indigo.

A small brushstroke of ultramarine blue above the higher rooftop defines the building's exterior here.

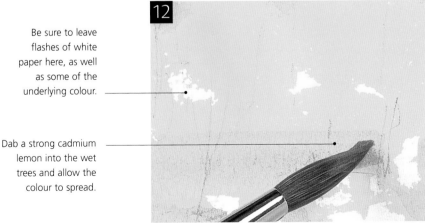

Be sure to leave flashes of white paper here, as well as some of the underlying colour.

Dab a strong cadmium lemon into the wet trees and allow the colour to spread.

Work sparingly here, wet on dry.

14 Mix cadmium lemon with burnt sienna and a little phthalo green. Drybrush this over the green on the left-hand riverbank. Leave to dry. Use indigo to brush in the shadows on the left-hand riverbank meadow below the trees. Take the shadows up into the tree trunks to join them to the trees.

15 With a #2 brush, paint a diluted glaze of burnt sienna onto the building roof, wet on dry. Touch the window shapes in with a little yellow ochre and some burnt sienna. Let the window apertures dry, then touch them in with a mix of ultramarine blue and burnt sienna.

16 Prepare some burnt sienna. Brush some clean water onto the left-hand riverbank. Use the point of a #2 brush to apply a wash of burnt sienna along the lower edge of the riverbank. Paint long, straight lines of shadow between the foliage and the grass after re-wetting the paper above them. Add indigo to some of the palette green, and with the point of a #2 brush, intensify the shadow and give the ground a definite surface.

17 You may want to return to certain parts of a painting to strengthen areas that have paled a little, compared with other parts where the tones have been built up. Here the distant poplars on the right-hand riverbank have been built up with a little more cerulean blue.

painting sequence

The shadow on the right-hand side has already been painted – the middle one is being brushed on.

Notice how the window apertures are just brushed in under the tops and down one side in a tiny triangle shape, leaving some of the previous colour showing.

Brush the burnt sienna onto the river bank, wet in wet.

Here, the distant poplars have been built up with a little more cerulean blue.

18 Prepare some ultramarine blue, and with a #2 brush apply it to the background. This adds recession into the furthest visible point down the river, often the focal point of a painting like this. Blue adds depth and gives the effect of looking right into the distance when placed at this point. Paint some cerulean blue and cobalt blue mixed over the distant riverbank in streaks. Many colours are added continuously into a wash of water and colour – the essence of the medium. Re-wet half the river from the top down to the middle with a large soft brush such as a hake, sable or squirrel. Use plenty of water. Bring the wet area down the right side to the base of the image, as there is an unbroken woodland reflection on this side. A #30 squirrel brush was used for this wet wash. Don't worry if the wash interferes with the colour underneath; it should settle down smoothly when it dries.

19 Dab a little gum arabic into the wet wash using a #12 brush. While it's still wet, brush darks down into the river. A mixture of Payne's grey and phthalo green was used for the tree reflections. Notice how they are soft focus, but under control because of the thickening effect of the gum arabic, which stops the colour from spreading, or diffusing into the wash. Continue to apply the dark colours quickly to the wet river wash. Notice how the masking shows with the darker colour applied over it.

Cerulean blue is painted over the distant wooded riverbank foliage.

Brush clear water onto the river, and then just a little gum arabic with a few strokes of the brush.

20 While it's still wet, add cadmium lemon fairly thickly into the distant river. Brush cerulean blue onto the distant river, and cadmium lemon following the right-hand riverbank back to the poplar trees.

21 With a #6 brush, apply burnt sienna streaked down into the wet wash reflecting the trees on the left-hand riverbank. Add cadmium lemon to the burnt sienna streaks on the left side.

22 Using a #2 brush, add Payne's grey to the wet wash on the distant river and drag these colours down vertically, for the look of deep, rich reflections. Darken the wash with more colours.

23 Add a mix of burnt sienna and phthalo green to the poplar tree reflections on the left. Keep adding colours to the wash – here phthalo green was added with cerulean blue. Colour is touched in with a smaller brush below the riverbank. Dry the entire wash carefully with a hairdryer. Drop cadmium lemon, wet in wet, into the darker colour.

painting sequence

Notice how the masking is beginning to show up.

The light colours are brushed into the river, wet in wet.

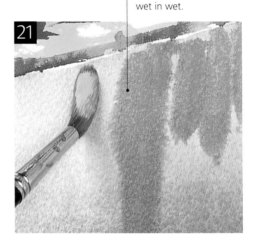

Burnt sienna and cadmium lemon are brushed down – keep working wet in wet.

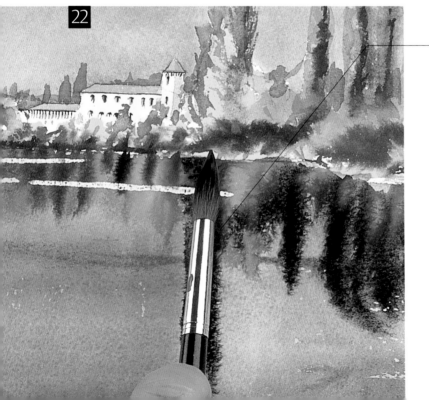

Darker colours, including Payne's grey, are brushed down vertically, working wet in wet.

Cadmium lemon, or a yellow mixed into white, is dabbed on for floating weed and lilies.

The Finished Painting Note how it is not the detailed areas of the painting that are the central points of interest here. Simplicity can be used to great effect, and here, although the effect of the water is little more than a superimposition of wet washes, a real sense of movement is created by the bend in the river and the use of light and reflection. The eye is immediately drawn into the picture, following the flow of the river framed by the poplar trees, to the villa, just visible as it emerges out of the leafy foliage.

Broad sunlit river

by Joe Francis Dowden

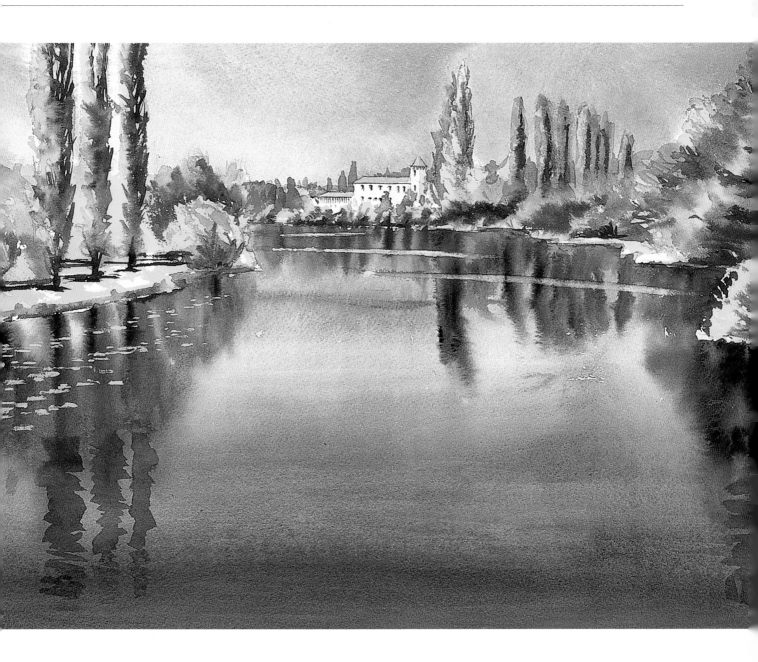

Index

A

aluminium foil, to use 49

B

branch effect 33
 in project 112–17
Broad sunlit river (Dowden) 118–25
brush(es) 10, 11
 to draw with 25, 27
buckling, to prevent 9
buildings 70–7, 98, 100–1, 102,
 118, 121, 122

C

Café at noon (Mellish) 70–7
candle *see* wax resist
cling film, to use 49
cloud effects 40–1, 46, 106–7, 108
colour(s) 8
 complementary 89
 to drop 50
 to layer 17
 to let in 32
 to lift 10, 46
colour mixing: to add water 15
 dark colours 16, 17
 different strengths 14
 for large areas 15
 pale colours 16
 for small areas 15
complementary colours 89

D

depth, effect of 60, 61
details 27
Dowden, Joe Francis: Broad sunlit
 river 118–25
 Copse of trees 112–17
 Sailing in Zanzibar 106–11
 Tuscan vineyard 98–105
drawing: preparatory 10

 with brush 25, 27
dropping colour technique 50
 in project 56–61, 98–105
drybrush technique 25, 26
 in project 76–83, 98–105, 118–25

E

edge(s): hard-and-soft 34–5
 lost 115
 lost-and-found 21
 in project 76–83
equipment 11

F

Family portrait (Mellish) 90–7
feathering technique 29
 in project 98–105, 106–11
fibres, brush 10
flat wash 18
Fletcher, Adelene: Wild poppies
 56–61
foliage effects 31, 38, 39, 50, 81,
 86–7, 113, 114, 115, 121
Fruit bowl (Rowntree) 62–9

G

glazing technique 37
 in project 90–7, 118–25
gouache 30
graded wash technique 19
 in project 70–7, 118–25
granulation medium 11, 45
granulation technique 44–5, 63
 in project 90–7
grass effect 30, 59
green, to mix 16, 17
grey, to mix 16
gum arabic 11, 53
 in project 118–25

H

hairdryer, to use 21, 35, 37, 84, 85,
 87, 88, 100, 119, 124
hard-and-soft edges 34–5
hatching 22
highlights, to create 30, 57, 64, 68,
 82, 87, 90

I

inks 22

L

layering technique 36, 88
leaves 65–7, 84, 86–7
 see also foliage effects
letting in colour 32
lifting colour technique 10, 46
 in project 90–7
light to dark 31
line and wash 22–3
lost edge 115
lost-and-found edges 21
 in project 76–83, 90–7, 98–105

M

masking/masking fluid 11, 42–3
 in project 56–61, 62–9, 84–9,
 112–17
 to remove 43
Mellish, Glynnis Barnes: Café at
 noon 70–7
 Family portrait 90–7
 Reading in the sun 76–83
mistakes, to correct 91, 94
mottling 33
multicoloured wash 20

N

negative shapes 10, 63, 65, 66, 67,
 77, 86, 93

O

open wash 32

ox gall liquid 11, 52–3

P

paint(s), watercolour 8, 11, 14

palette, suggested 8

paper, watercolour: to stretch 9

 types 9, 11

Parrot in wild thicket (Topham) 84–9

pencils 10, 11

pens 11

poppies 32, 56–61

portraits 90–7

R

Reading in the sun (Mellish) 76–83

reflections in water 53, 110, 113,

 123, 124

Rowntree, Julia: Fruit bowl 62–9

S

Sailing in Zanzibar (Dowden) 106–11

salt 11, 48–9

saving whites technique 40–1

 in project 84–9, 98–105, 106–11,

 112–17, 118–25

scratching out 51

 in project 84–9

 using cotton bud 66

sgraffito 51

 see also scratching out

shadow(s) 39, 64, 68, 73, 74, 78,

 82, 88, 94, 101, 122

sketch, preparatory 10

skin tones 90–2, 94–5

sky effects 19, 20, 52–3, 70, 106–7,

 119

 see also cloud effects

spattering technique: in project

 76–83, 84–9, 112–17

wet-in-wet 39

wet-on-dry 38

 see also mottling

sponging 47

stems 59, 60

still life 62–9

stippling technique 28

sunlight effects 59, 112

T

techniques: colour mixing 14–17

 detail 27

 dropping 50

 drybrush 25, 26

 feathering 29

 flat wash 18

 glazing 37

 gouache 30

 graded wash 19

 granulation 44–5

 gum arabic 53

 hard-and-soft edges 34–5

 layering 36

 letting colour in 32

 lifting colour 46

 light to dark 31

 line and wash 22–3

 lost-and-found edges 21

 masking 42–3

 mottling 33

 multicoloured wash 20

 ox gall liquid 52–3

 salt 48–9

 saving whites 40–1

 sgraffito 51

 spattering 38–9

 sponging 47

 stippling 28

 tissue paper 46

wax resist 43

wet in wet 24

wet on dry 25

texture, to create 26, 28, 39, 47, 49

tints 16

tissue paper, to use 46

Topham, Mark: Parrot in wild thicket

 84–9

tracing 62, 98

Tuscan vineyard (Dowden) 98–105

W

wash(es): consistency of 24

 flat 18

 graded 19

 in project 70–7, 118–25

 line and 22–3

 multicoloured 20

 open 32

 see also glazing technique

water spray, to use 85, 86

waterscapes 106–11, 118–25

wax resist technique 43

 in project 76–83

weight (of paper) 9

wet-in-wet technique 14, 24

wet-on-dry technique 25

whites, saved 21–2

Wild poppies (Fletcher) 56–61

Credits

Quarto would like to thank the following individuals who took part in the step-by-step demonstrations: Glynnis Barnes Mellish, Adelene Fletcher, Julia Rowntree, Mark Topham.

Many thanks to Henry Wyatt at Art Club at the Triumph Press for providing materials and equipment used throughout the book. (Triumph Press, 91 High Street, Edgware, Middlesex, HA8 7DB, tel: +44 (0) 208 951 3883)

The author would like to extend grateful thanks to Christopher Barford and Rita Stappard for encouragement in all his endeavours.

All other photographs and illustrations are the copyright of Quarto Publishing plc. While every effort has been made to credit contributors, we would like to apologise in advance if there have been any omissions or errors.